BIRD MUG SHOTS

A Unique Look at North America's ⭐**MOST WANTED**⭐ Birds

TEXT & PHOTOS BY

EARL ORF
WITH
VAL CUNNINGHAM

To my wonderful wife,

Diana,

who encouraged me to pursue my interest in photography and patiently
endured sudden stops while I jumped out of the car to take a picture of a bird.
She also read all the text in this book and made many suggestions to improve
the content.
—Earl

To *Rog,*
the best kind of birder
—Val

...

Stone Ridge Press
2515 Garthus Road
Wrenshall, MN 55797
www.StoneRidgePress.com
thesparkygroup@gmail.com

Bird Mug Shots: A Unique Look at North America's Most Wanted Birds

Printed in Canada by Friesens
10 9 8 7 6 5 4 3 2 1 First Edition
Graphic Design by Sparky Stensaas of Stone Ridge Press
Cover photo of Atlantic Puffin by Earl Orf

ISBN-13: 978-0-9909158-8-1

Table of Contents

2 How this Project took Flight
4 Trumpeter Swan
5 Canada Goose
6 Common Goldeneye
7 White-winged Scoter
8 Common Eider
9 Redhead
10 Ring-necked Duck
11 Lesser Scaup
12 American Wigeon
13 Bufflehead
14 Common Loon
15 Common Merganser
16 Horned Grebe (breeding)
17 Horned Grebe (non-breeding)
18 American White Pelican
19 Brown Pelican
20 White Ibis
21 Roseate Spoonbill
22 Tricolored Heron
23 Great Blue Heron
24 Cattle Egret
25 Snowy Egret
26 Least Bittern
27 Virginia Rail
28 Ruddy Turnstone
29 Black Oystercatcher
30 Royal Tern
31 Ring-billed Gull
32 Atlantic Puffin
33 Razorbill
34 Harris's Hawk
35 Cooper's Hawk
36 Snail Kite
37 Crested Caracara
38 Osprey (adult)

39 Osprey (juvenile)
40 American Kestrel
41 Peregrine Falcon
42 Bald Eagle
43 Short-eared Owl
44 Great Gray Owl
45 Barred Owl
46 Eastern Screech-Owl
47 Great Horned Owl
48 Spruce Grouse
49 Ruffed Grouse
50 Greater Roadrunner
51 Ruby-throated Hummingbird
52 Green Kingfisher
53 Yellow-bellied Sapsucker
54 Downy Woodpecker
55 Hairy Woodpecker
56 Red-bellied Woodpecker
57 Pileated Woodpecker
58 Red-eyed Vireo
59 Blue-headed Vireo
60 Yellow-throated Vireo
61 Common Raven
62 Blue Jay
63 Green Jay
64 Black-capped Chickadee
65 Golden-crowned Kinglet
66 American Robin
67 Eastern Bluebird
68 Northern Mockingbird
69 Cedar Waxwing
70 Chestnut-sided Warbler
 (breeding)
71 Chestnut-sided Warbler
 (non-breeding)
72 Northern Parula

73 Blackburnian Warbler
74 American Redstart
75 Black-and-white Warbler
76 Cape May Warbler
77 Nashville Warbler
78 Magnolia Warbler
79 Black-throated Green
 Warbler
80 Yellow-rumped (Myrtle)
 Warbler
81 Yellow-rumped (Audubon's)
 Warbler
82 Golden-winged Warbler
83 Canada Warbler
84 Common Yellowthroat
85 Yellow Warbler
86 Northern Cardinal
87 Painted Bunting
88 Olive Sparrow
89 American Tree Sparrow
90 Fox Sparrow
91 Clay-colored Sparrow
92 Black-throated Sparrow
93 Bachman's Sparrow
94 White-crowned Sparrow
95 White-throated Sparrow
96 Red-winged Blackbird
97 Yellow-headed Blackbird
98 Bobolink
99 Boat-tailed Grackle
100 Baltimore Oriole
101 American Goldfinch
102 Evening Grosbeak
103 Pine Grosbeak
104 "Two-for-Ones"
106 Glossary

HOW THIS PROJECT TOOK FLIGHT

I'm hooked, and these two photos got me started. I photographed these Black Skimmers on Jekyll Island, Georgia, in January 2005. Like most bird photographers, I was trying for shots like the one that shows a side view. However, after I downloaded my photos and saw the one showing the front view, I could hardly believe my eyes!

I've seen lots of Black Skimmers and I already knew their beaks were unique. In the side view, the upper mandible looks like it has been broken off, but it's actually supposed to be shorter than the lower mandible. Like all things in nature, there's a good reason for

that. These birds feed by flying just above the surface of the ocean with their lower mandible in the water. When they touch something edible, the upper mandible snaps shut and they have a meal. Because they rely on touch to catch their food, they can feed in low light situations or at night.

The Birder's Handbook says that a skimmer's lower mandible grows at twice the rate of its upper mandible. This is because the lower mandible is worn down faster from slicing through the water.

The side view makes the beak look very substantial, but the front view reveals that it is actually as

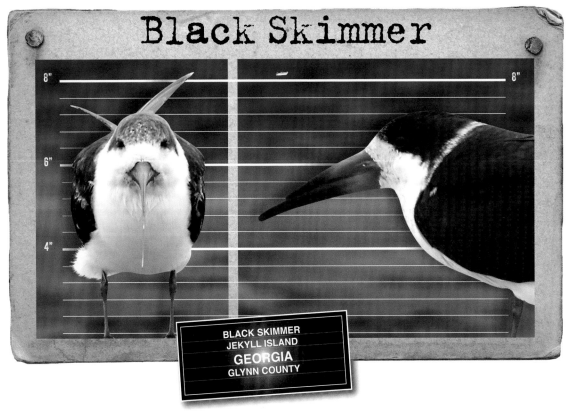

Black Skimmer

8" 8"
6"
4"

BLACK SKIMMER
JEKYLL ISLAND
GEORGIA
GLYNN COUNTY

Great Gray Owl

22"
18"
14"
22"
18"

GREAT GRAY OWL
COUNTY ROAD 72
MINNESOTA
ITASCA COUNTY

thin as a knife blade. Well, of course! That would allow it to slice through the water with a minimum of friction. This was an *"aha"* moment for me.

Putting a side view and a front view next to each other reminded me of the mug shots you used to see in post offices, showing people suspected of crimes. This set of Black Skimmer "mug shots" made me curious.

The conventional goal of bird photographers is to get profile shots like the side view. That's the view you see in all the field guides. Most photographers consider a shot of a bird that is directly facing toward them to be a mistake and discard it immediately. But I had just learned something very interesting about Black Skimmers from my mug shot. What else could I learn about other birds if I took "head on" photos and compared them to profile shots?

That's how I got hooked. Now I can't stop taking front views when I'm photographing birds. I actually *try* for those shots so I can assemble more "mug shots." Some of them reveal interesting features of the bird,

while others are just plain funny.

Owl photos present a special case. I stated above that most photographers delete photos that show a "face forward" shot of a bird. That's just the opposite with owls. Most of the time, photos of owls show a front view of the face. Why? Maybe it's because they have a more human-like face with their large forward-facing eyes.

Join me as we look at more bird mug shots. See these birds from a new perspective. Learn new information and have a laugh at the same time. –Earl Orf

KEY TO RANGE MAPS

= year round

= year round (scarce)

= winter

= summer

= summer (scarce)

= migration

WHAT DO YOU SEE?

It's your turn! Scattered throughout the book you'll see this "What do you see?" banner. Since the purpose of this book is to look at birds in a new way, why not try your hand at jotting down some interesting observations for these front and side views. I guarantee you'll never look at a bird from the same angle again.

3

Trumpeter Swan

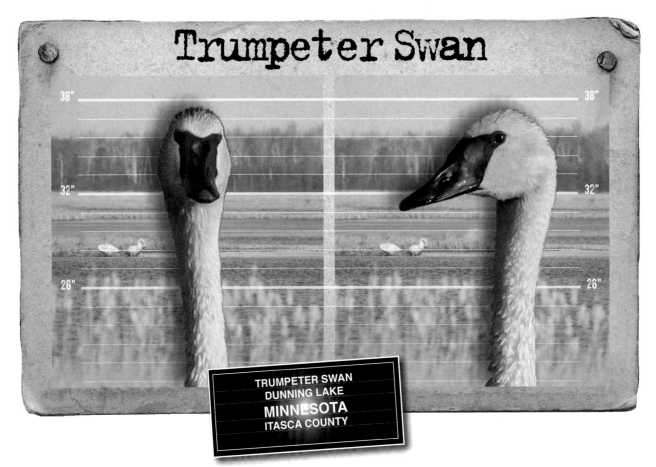

38"
32"
26"
38"
32"
26"

TRUMPETER SWAN
DUNNING LAKE
MINNESOTA
ITASCA COUNTY

MUG SHOT: The Trumpeter Swan is a very large, all-white bird with a long neck. In the front view, the swan's long, black bill is uniformly wide with a rounded tip. White feathers form a V shape at the base of the bill. In the side view, the bill is a triangular shape. A patch of featherless black skin surrounds the eyes and connects to the bill. Mud-stained feathers on top of the head are visible in the front view. –EO

NATURAL HISTORY: Pushed to the edge of extinction after being over-hunted for food and fashion, Trumpeter Swans are now returning to parts of their former range, thanks to vigorous restoration programs and dedicated volunteers. They're our largest native waterfowl. Such heavy-bodied birds need a long runway to become airborne, their big, black feet slapping the water before lift-off. They eat primarily plant matter, including pondweed, eelgrass, sedges, rushes and wild rice. Trumpeters form strong family bonds, and young swans travel with their parents on their first migration. –VC

Canada Goose

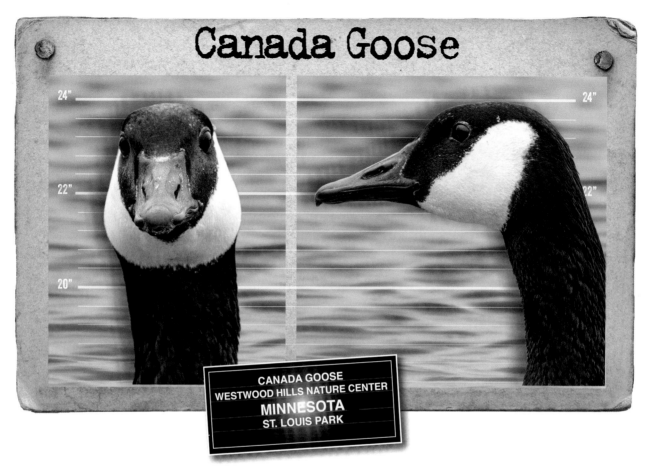

CANADA GOOSE
WESTWOOD HILLS NATURE CENTER
MINNESOTA
ST. LOUIS PARK

MUG SHOT: The front view of this Canada Goose looks like the old-time photo of a person with a toothache and a white rag wrapped around the head. Like a duck, a goose has a hardened tip, called a nail, at the end of its bill. In these photos, the nail is hard to detect but the front view shows it as an oval shape at the tip of the bill. The side view shows a hooked end on the nail. –EO

NATURAL HISTORY: Known to many as the "golf course geese," they're a familiar sight on fairways, as well as in parks and at airports with low-cut grass. Such areas offer a panoramic view to parent birds looking to protect goslings from predators. The Giant Canada Goose subspecies was once nearing extinction in North America, and programs to restore its population have been so successful that the birds are often considered a nuisance. They're good parents, with both male and female caring for their youngsters and guiding them on their first migration. –VC

Common Goldeneye

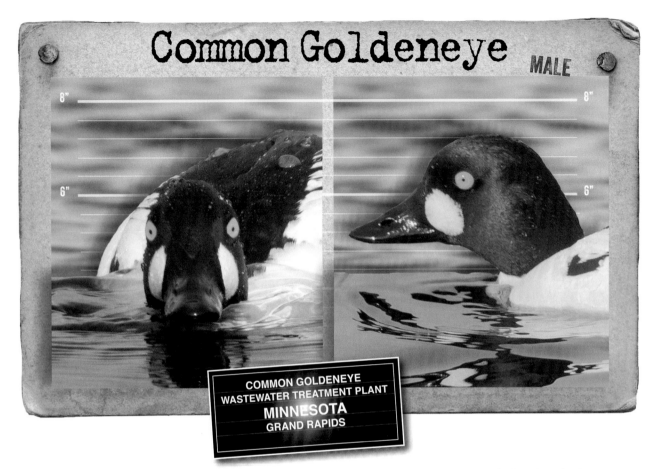

MALE

8"

6"

8"

6"

COMMON GOLDENEYE
WASTEWATER TREATMENT PLANT
MINNESOTA
GRAND RAPIDS

MUG SHOT: The bright yellow eyes confirm that Common Goldeneye is a great name for this duck. This is a male; a female has a brown head and gray body. The feathers on the male's head are black but may look green when seen from a certain angle and catching the sunlight. The oval white patches on each cheek outline the sides of the bill in the front view. The goldeneye has a large head relative to its body size and the stubby bill makes the head look even bigger. –EO

NATURAL HISTORY: Look for this duck in winter along coastal areas or on large inland lakes and rivers, where flocks dive for fish and crustaceans such as crab, shrimp, crayfish and mussels. Common Goldeneye females lay their eggs in tree holes, tops of snags and in human-made nest boxes—these can be as high as 40 feet above ground. The day after her eggs hatch, the female stands below the nest site and calls for her brood to jump and tumble to the ground. Hunters call this duck the "whistler," for the loud whistling sound made by its wings in flight. –VC

White-winged Scoter

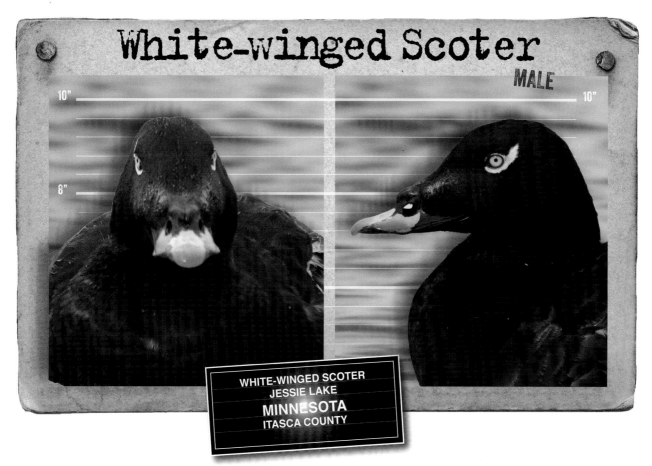

MALE

10"

10"

8"

WHITE-WINGED SCOTER
JESSIE LAKE
MINNESOTA
ITASCA COUNTY

MUG SHOT: No doubt about it, the White-winged Scoter is a strange-looking duck. To begin with, it has a hump in the middle of its bill with a large hole through it. In the front view, the hump looks more like the nose of a dog and the pink patches on the bill look like big canine teeth. The large orange nail at the end of the bill could be mistaken for the dog's tongue. How odd! Note the white comma-shaped patch of feathers around each eye. –EO

NATURAL HISTORY: The best chance to catch sight of this large sea duck is as it travels from its summer breeding areas in northwestern Canada to coastal areas to spend the winter. Watch for long lines of White-winged Scoters flying a few feet above the water's surface as they move southward. This diving duck feeds mainly on clams and mussels, but also adds shellfish and aquatic insects to its diet. The White-winged Scoter population in the Great Lakes is benefiting from an invasion of Zebra Mussels, a small mollusk that's increasingly detrimental to freshwater lakes and streams. –VC

Common Eider

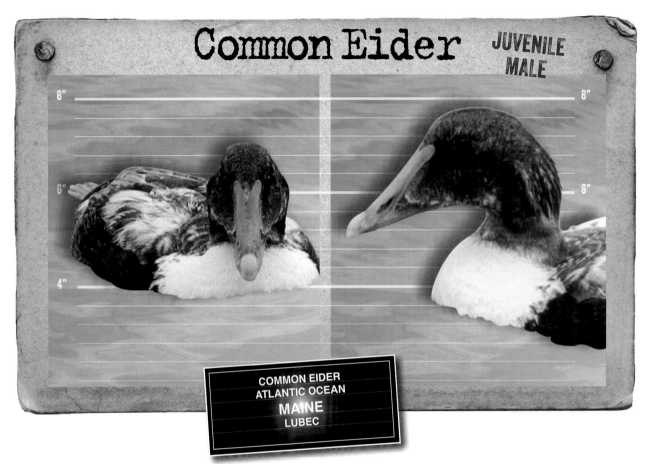

COMMON EIDER
ATLANTIC OCEAN
MAINE
LUBEC

MUG SHOT: The side view of this juvenile male Common Eider shows the wedge shape of his bill. It's quite different from the flatter bill shape of most ducks. (See Redhead on next page for comparison.) The front view confirms that the bill extends upward close to the top of his head. It also shows the large pale bill nail that might be helpful in grasping crabs and other marine animals. A duck's bill is generally the same width along its the entire length, as you can see in the front view. –EO

NATURAL HISTORY: This large, diving sea duck lives along the coasts of Alaska, Hudson Bay, eastern Canada and northern Maine. To withstand frigid waters, eiders have heavy undercoats of downy feathers, prized for their softness and insulating qualities. Some countries raise the ducks commercially, harvesting down from used nests to put in pillows, sleeping bags and parkas. These ducks have a distinctive profile, with their elongated heads and long, sloping bills. Eiders remain close to the coast and dive as far as the sea floor to snap up mussels, clams, sea urchins and other prey, swallowing them whole to be ground up by their gizzards. –VC

Redhead

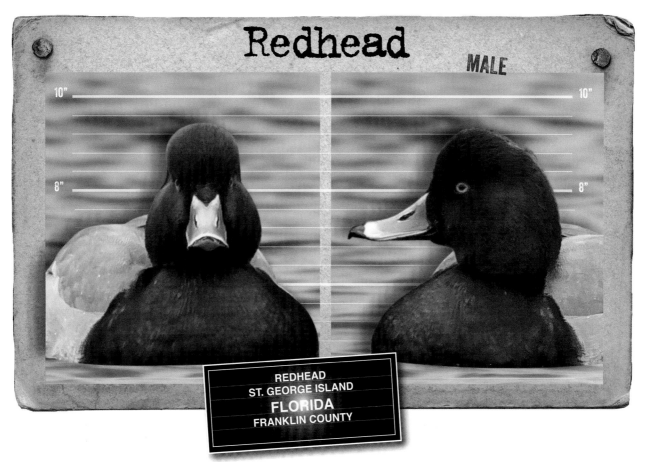

MALE

10" 10"

8" 8"

REDHEAD
ST. GEORGE ISLAND
FLORIDA
FRANKLIN COUNTY

MUG SHOT: Did someone use a tire pump to inflate this duck? The side view gives a pretty normal "duck" look to this male Redhead but the front view makes him look like a balloon ready to pop. In the side view, the light blue bill gets gradually lighter toward the front. In the front view, this light area shows up as a white semi-circle above the black bill tip. The side view doesn't even show how the feathers form a V shape at the top of the bill. –EO

NATURAL HISTORY: A raft of these ducks floating in the middle of a lake or off the coast resembles most other duck gatherings, until the sun lights up those brilliant, deep-red heads. Yes, Redheads are easy to identify (if we don't confuse them with their look-alike cousin, the Canvasback), and their bill is another standout feature, with its bluish tint, white ring and black tip. These are diving ducks that sometimes tip up and dabble, as Mallards do, foraging on plant tubers, small snails and mussels, fish eggs and aquatic insects. They're a very social duck and are almost always found in large groups. –VC

Ring-necked Duck

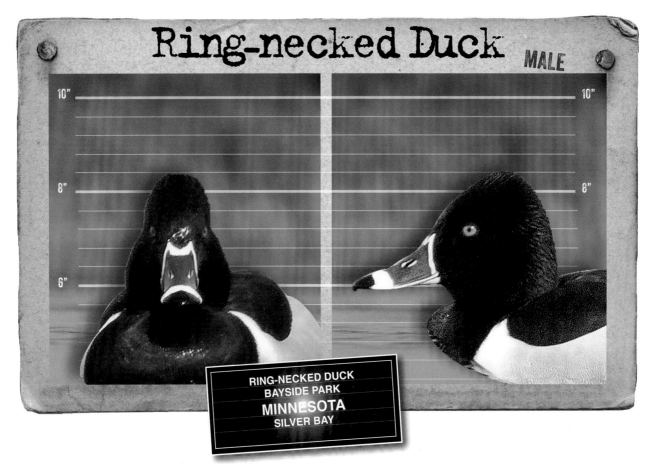

RING-NECKED DUCK
BAYSIDE PARK
MINNESOTA
SILVER BAY

MUG SHOT: The Ring-necked Duck does have a ring around its neck but it is not usually visible. It is almost the same color as the rest of the neck so it doesn't stand out. Also, when the duck has its head in a lowered, relaxed position as shown here, the ring is hidden. The white rings around the bill are much more prominent, so perhaps "Ring-billed Duck" would be a more appropriate name. The side view shows that the nail is quite large and there is a slight hook on the end of it. –EO

NATURAL HISTORY: This duck, unique among diving ducks, prefers shallow water, and is often found in freshwater wetlands, making short dives for plant food, insects and clams. Its diet consists mainly of seeds, stems or tubers of pondweed, water lily, wild celery, arrowhead, sedges and wild rice. In fact, Ring-necked Ducks may gather by the hundreds of thousands during fall migration to feed on wild rice in northern lakes. Even without a view of its distinctive bill, this duck can be told from either of the scaups by its peaked head and black back. They're one of the first ducks to pass through on spring migration. –VC

Lesser Scaup

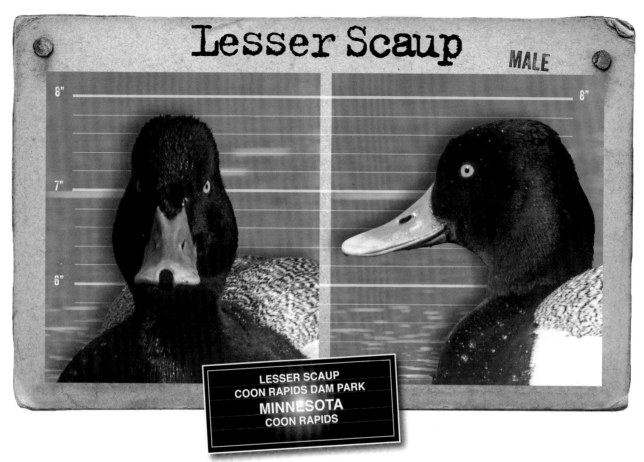

MALE

8" 8"
7"
6"

LESSER SCAUP
COON RAPIDS DAM PARK
MINNESOTA
COON RAPIDS

MUG SHOT: The side view of this male Lesser Scaup doesn't even show the dark tip at the end of his bill. This bill tip is called a nail: All ducks have a soft, skin-like membrane that covers their bills and they also have a nail made of hard material. Nail size differs on various species of ducks. The Lesser Scaup has a rather small nail so it's not visible in the side view. Also notice, in the front view, that two ridges on the top of the bill form a V-shape of feathers. –EO

NATURAL HISTORY: This medium-sized duck makes frequent dives in search of a meal, disappearing in a sinuous maneuver. Known to hunters as "bluebills," Lesser Scaup feast on mussels, clams and snails, as well as aquatic vegetation, insects and seeds. In winter they gather on freshwater lakes and ponds in groups that may number in the thousands. This handsome duck is a challenge to tell apart from the lookalike Greater Scaup, and even experienced birdwatchers can be fooled. This is one of the most abundant diving ducks in North America, but its population has been declining since the 1960s. –VC

American Wigeon

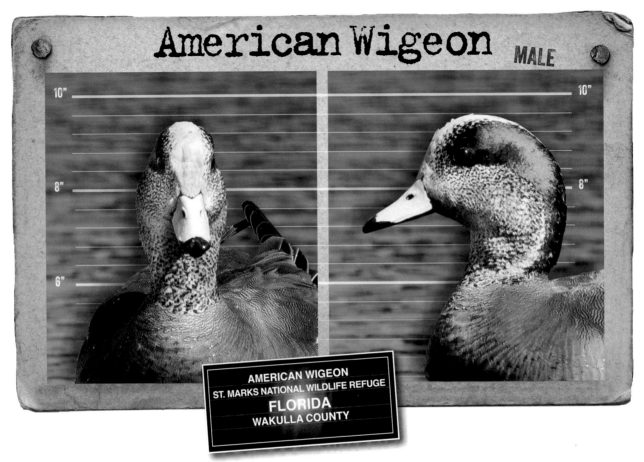

AMERICAN WIGEON
ST. MARKS NATIONAL WILDLIFE REFUGE
FLORIDA
WAKULLA COUNTY

MUG SHOT: The green feathers on this male American Wigeon's head can't be seen in the front view but are visible in the side view. However, the front view does emphasize the white feathers that extend from the base of the bill to the back of the head. This is reminiscent of a bald-headed man so some people call it by the humorous name of "baldpate." Wigeons have a fairly short bill for a duck, but a rather prominent nail. –EO

NATURAL HISTORY: American Wigeons stand out in mixed flocks of ducks for their conspicuous white head stripe. This small duck breeds in northwestern North America, but can be found across most of the southern tier of states during migration or winter. They dabble to feed on leaves and roots of submerged vegetation, tipping into a head-down position to feed on the bottom of shallow waters. They earned the nickname, "poacher," for their habit of following diving birds like coots, waiting on the surface for them to emerge, and then snatching any vegetation they drop, even grabbing food from the others' bills. –VC

12

Bufflehead

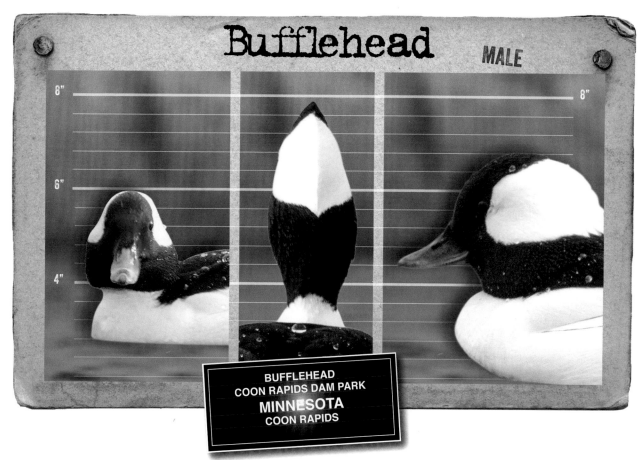

8"

6"

4"

8"

**BUFFLEHEAD
COON RAPIDS DAM PARK
MINNESOTA
COON RAPIDS**

MUG SHOT: The front view of this male Bufflehead makes it look like he's wearing a white cap. The other photos show the white feathers going around to the back of the head. Perhaps the photo from the back inspired the ducktail haircut popular in the 1950s. In the back view, the dark feathers look black. However, in the front and side views, the feathers on the bird's head look purple, an example of iridescence, which means that color is only visible when the feathers are lit from a certain angle. –EO

NATURAL HISTORY: This tiny diving duck with its large, puffy head is easy to spot on lakes and bays, with its dark plumage on a predominantly white body and its blue-gray bill. Because they store so much fat for migration, they are sometimes called "butterballs." Buffleheads are buoyant ducks, diving after a forward leap, abruptly disappearing and just as abruptly reappearing. They remain underwater for short stints in search of aquatic insects in freshwater and crustaceans in saltwater. This duck, like several other duck species, nests in tree cavities, and almost always chooses an old Northern Flicker hole in Canada's boreal forest for raising its family. –VC

Common Loon

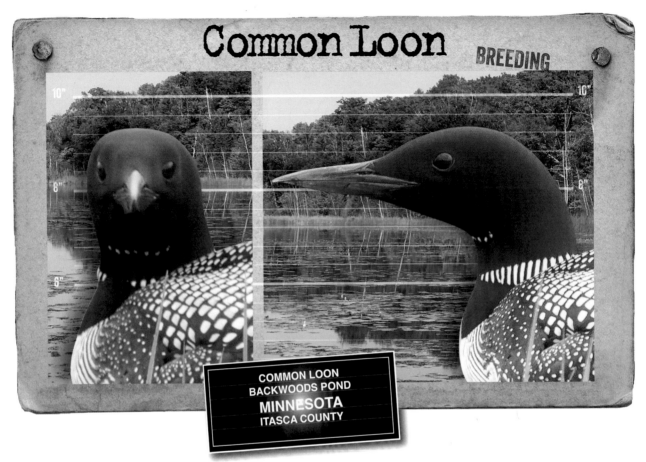

COMMON LOON
BACKWOODS POND
MINNESOTA
ITASCA COUNTY

MUG SHOT: Loons often choose a remote, undisturbed lake to raise a family. This one, however, built its nest about 30 feet from the road, along one of the busiest highways in northern Minnesota. The side view shows the sturdy, sharp beak, but that beak almost disappears when seen from the front. Loons can use their beaks as formidable weapons of defense. This loon looks elegant in the side view but, quite honestly, it looks kind of "dopey" from the front. –EO

NATURAL HISTORY: Loons spend nearly all of their lives in the water, only coming ashore during nesting season. These are birds of North Woods waters, and their eerie, echoing yodels and wails evoke the wilderness to many people. They're expert swimmers and pursue their prey—often sunfish or perch—underwater, executing 180-degree turns in a flash. Loons will cruise the shallows with head under water, watching for fish, then diving without a splash. Their legs, set far back on their bodies, are well placed for swimming but make them awkward on land. They need a long stretch of water for their running takeoffs. –VC

Common Merganser

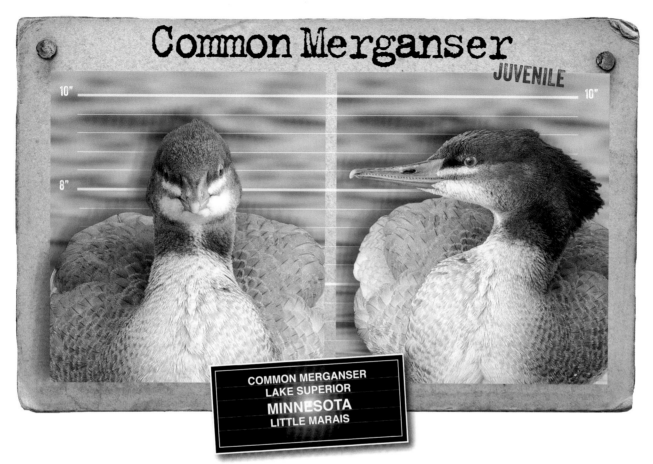

JUVENILE

10"

10"

8"

**COMMON MERGANSER
LAKE SUPERIOR
MINNESOTA
LITTLE MARAIS**

MUG SHOT: In the side view of this Common Merganser, the serrated edge of its bill is clearly seen. This toothy feature inspired the nickname "sawbill." The sharp-edged bill and the hooked yellow nail at the end of the bill are essential for catching and gripping the slippery fish that mergansers eat. The front view shows how thin the bill is, not at all like a typical duck bill. Both views clearly show the white stripe under the eye and the white chin. –EO

NATURAL HISTORY: Female and juvenile mergansers can be tricky to identify, but the male Common Merganser is striking, with his green head, white flanks and red bill. It patrols on the surface of clear lakes and streams, head dipped in the water as it watches for small fish, then dives with a small leap and swims swiftly after its prey, propelled by strong feet. The serrated edges of its bill help the Common Merganser hold on to fish caught during these frequent underwater dives. They raise their young in nests inside tree cavities made by woodpeckers or in human-made nest boxes near streams and lakes. –VC

Horned Grebe

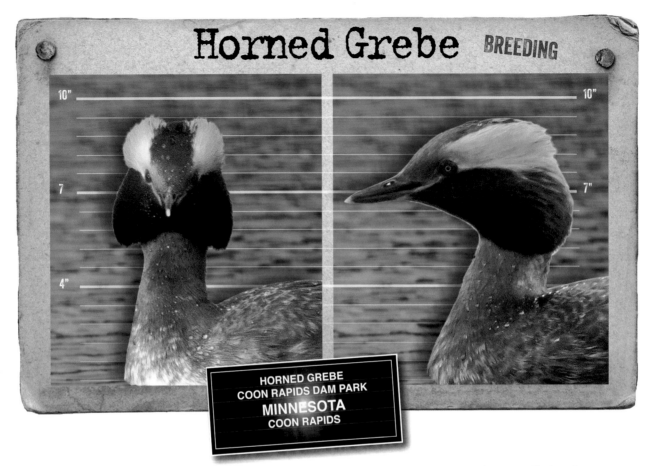

10"

7"

4"

10"

7"

HORNED GREBE
COON RAPIDS DAM PARK
MINNESOTA
COON RAPIDS

MUG SHOT: This Horned Grebe is in breeding plumage. The side view shows the red neck, black and gold feathers on the head, yellow tip on the beak and the red eyes. But the front view reveals how much those black feathers stick out from the neck. It looks like the bird has a muff around its neck or a big, black beard. The gold feathers look like a halo around the head. When the bird is excited, it can raise those feathers so they look like horns, which is how the bird got its name. –EO

NATURAL HISTORY: These small, handsome water birds are excellent swimmers and divers. In fact, when pursuing a fish, a Horned Grebe might remain underwater for up to three minutes. They spend their summers on northern lakes that feature both open water and marsh vegetation. As loon chicks do, Horned Grebe chicks ride on their parents' backs when very young. Also like loons, these grebes need to patter across the water's surface until they become airborne. They have the unusual habit of consuming some of their own feathers, which may serve the purpose of lining the stomach as protection against fish bones. –VC

Horned Grebe NON-BREEDING

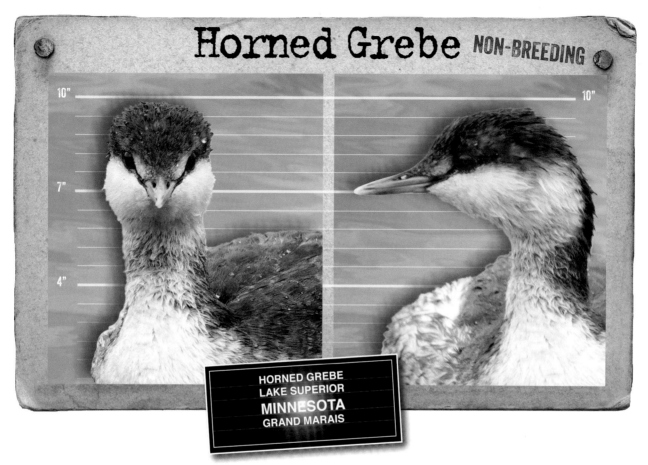

HORNED GREBE
LAKE SUPERIOR
MINNESOTA
GRAND MARAIS

MUG SHOT: This is also a Horned Grebe, but shown in non-breeding plumage. It's certainly a dramatic change from its breeding plumage, although the bird still has the yellow tip on the beak and the red eyes. And, if you compare this side view with the breeding plumage side view, you'll see that the shape of the head and beak are the same. But these photos are not nearly as spectacular as the photos showing breeding plumage. Gone are the "horns" and the "ruff." –EO

American White Pelican

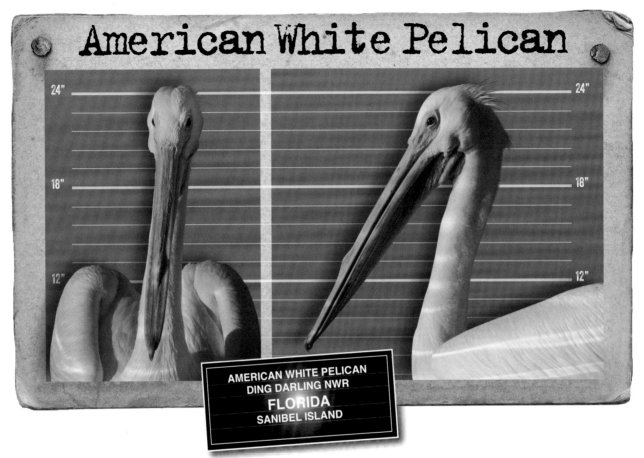

AMERICAN WHITE PELICAN
DING DARLING NWR
FLORIDA
SANIBEL ISLAND

MUG SHOT: The American White Pelican has one of the largest bills of any North American bird species, but the front view shows that it is not unusually wide. The side view reveals a hooked tip on the bill. In both views, you see a slight bump on the top of the bill. This is the start of a half-circle-shaped plate that probably has some courtship function because it disappears after the breeding season. In the front view, the folded wings form a raised border around the body. –EO

NATURAL HISTORY: Pelicans are a beautiful sight as they soar and wheel in flocks high in the air on long, black-tipped wings. Unlike their cousin the Brown Pelican, American White Pelicans don't plunge-dive for fish. Instead, they scoop them up with their massive bills, letting water run out the sides before swallowing. They sometimes work in a group, forming a circle and flapping their wings or dipping their bills in unison. In this way they herd fish into an ever-tightening corral as they move into the shallows, then easily feast on their prey. These birds breed inland but winter along the coasts. –VC

Brown Pelican

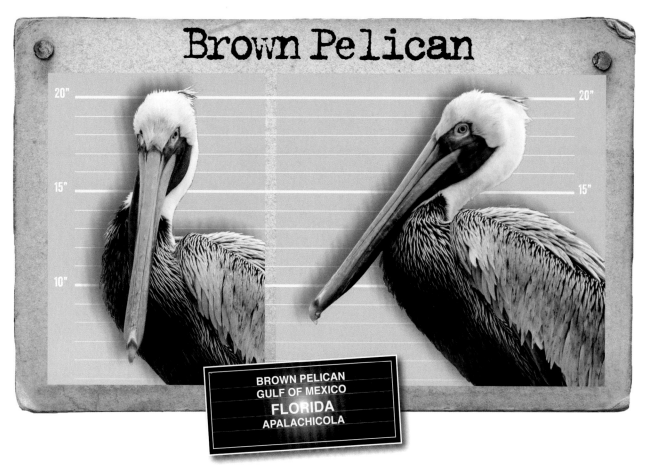

BROWN PELICAN
GULF OF MEXICO
FLORIDA
APALACHICOLA

MUG SHOT: The Brown Pelican has an extremely long bill but the front view shows that it is also very thin. The underside of the lower mandible is a flexible pouch that fills with water when the pelican dives for fish. Part of this black pouch can be seen in the side view, between the white neck feathers and the pink bill. Both views show the yellow nail at the end of the bill and the side view confirms that the nail is sharply hooked. –EO

NATURAL HISTORY: Visitors to Western and Southern coastal areas are familiar with the sight of a flock of these large, handsome birds gliding effortlessly over the waves. When a Brown Pelican spots a school of small fish, it rises into the air, then plunge-dives into the water, its impact stunning the fish long enough for the pelican to scoop them into its bill. Gulls show up as pelicans drain water from their bills, hoping to scoop up any fish that fall out. Once seriously endangered by the effects of pesticides, this bird's recovery has been a conservation success story, following the DDT ban in the early 1970s. –VC

White Ibis

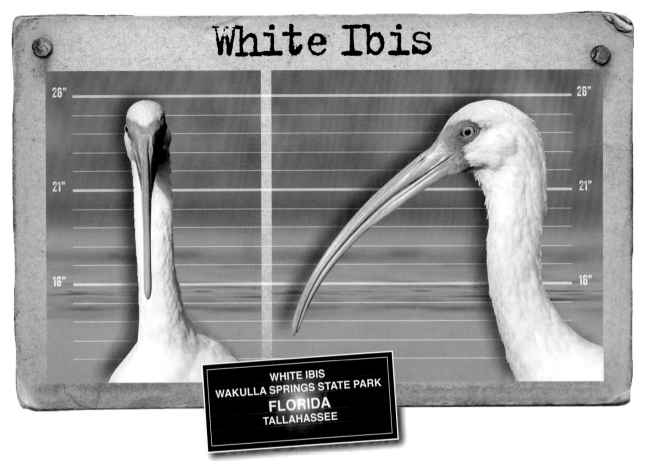

26"

21"

16"

26"

21"

16"

WHITE IBIS
WAKULLA SPRINGS STATE PARK
FLORIDA
TALLAHASSEE

MUG SHOT: This White Ibis looks dramatically different from the front and the side. The front view gives the impression that the beak is long, but doesn't show how curved it really is. This curved shape allows the ibis to feed on the ground or in the water and still keep its eyes looking upward to watch for predators. The bare skin on its face and around its eyes helps the ibis stay clean when it is probing in the mud. The beautiful blue eyes are unusual for a bird. —EO

NATURAL HISTORY: These striking white wading birds make a bold first impression, with their bright red beaks and long red legs. Anyone who's spent time in Florida has probably seen this ibis, whose favorite haunts include coastal marshes, mangrove swamps and even grassy lawns. An ibis uses its long, curved beak to probe for crayfish, crabs and insects under the mud. When foraging in shallow water, it stirs things up by swinging its beak from side to side. They're highly social, nesting in colonies with other wading birds, such as spoonbills and egrets. —VC

Roseate Spoonbill

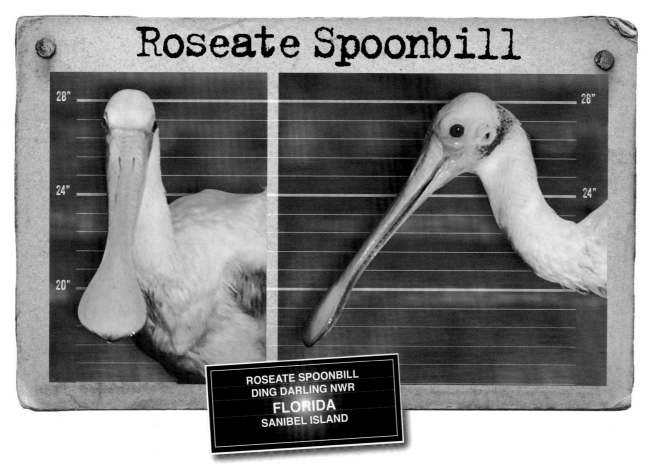

ROSEATE SPOONBILL
DING DARLING NWR
FLORIDA
SANIBEL ISLAND

MUG SHOT: The Roseate Spoonbill has one of the most uniquely shaped bills of any bird. That is much more obvious from a front view, which shows how wide the bill is along its entire length. The spoon-shaped tip of the bill is also very visible in the front view. But you need the side view to see the details of its unique, bald head. You can actually see the ears of this bird because there are no feathers covering them. The blood-red eye compliments the pink tone of the wing feathers. –EO

NATURAL HISTORY: This distinctive wading bird, with its lovely pink feathers and unusual spoon-shaped bill, is found year-round in coastal Florida, Texas and southwest Louisiana. Many people think they're seeing a flamingo at first, until they catch sight of that bill. A spoonbill forages in the shallows, swinging its head from side to side to scoop up muck, and then straining it through the bill's comb-like filters to pull out fish, shrimp, mollusks, snails and insects. They're usually seen in small flocks or flying overhead in elegant formation. This member of the ibis family is found throughout the Caribbean and is widespread in South America. –VC

Tricolored Heron

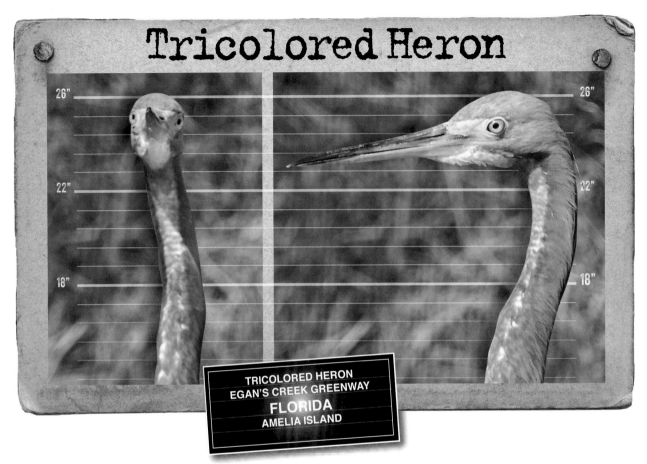

26"

22"

18"

26"

22"

18"

TRICOLORED HERON
EGAN'S CREEK GREENWAY
FLORIDA
AMELIA ISLAND

MUG SHOT: The Tricolored Heron has a very long neck, longer than the rest of its body. The size of its head and the length of its beak seem greatly reduced when seen in the front view. Also note that it has a bi-colored beak, dark on the top and yellow on the bottom. There is a patch of bare, yellow skin between the eye and beak. This bird is in non-breeding plumage. During the breeding season, its beak will be bright blue with a dark tip and its eyes will be red. —EO

NATURAL HISTORY: This handsome heron, with its cinnamon and slate gray neck and back and contrasting white belly, is ideally suited to stalk prey in quiet waters in marshes, swamps and streams in coastal lowlands. It uses its long legs to pursue small fish, and is often seen striding belly-deep through the water. Tricolored Herons sometimes hunt by running with wings outstretched to startle fish in the shallows into movement, making them easier to see and catch. Look for this medium-sized heron along the Atlantic and Gulf Coasts. They hunt alone but nest in crowded colonies made up of several kinds of wading birds. –VC

Great Blue Heron

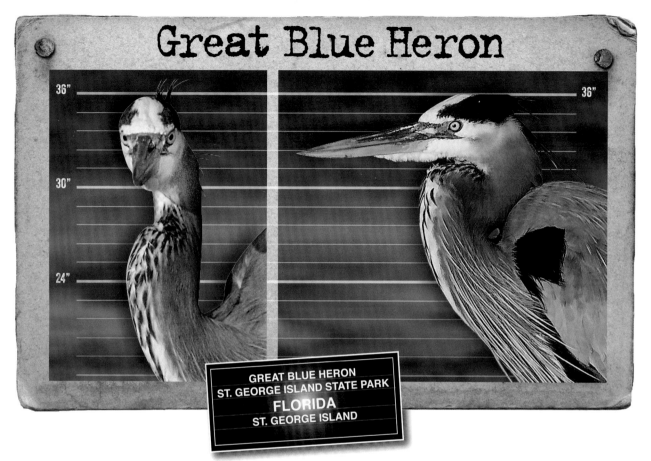

36"

30"

24"

36"

GREAT BLUE HERON
ST. GEORGE ISLAND STATE PARK
FLORIDA
ST. GEORGE ISLAND

MUG SHOT: The large, sturdy beak of this Great Blue Heron almost disappears when you view the bird from the front. That front view also makes the head look considerably smaller and does a better job of showing the dark brown spots on the Great Blue Heron's neck. The side view shows that the feathers under the beak extend out about half the length of the beak, which is not evident in the front view. –EO

NATURAL HISTORY: These tall wading birds, the largest herons in North America, are an impressive sight as they stand motionless in shallow water, waiting for a fish, frog or other prey to come into view. Their diet is not strictly aquatic, however, because they also hunt small mammals and insects in open fields. A heron will stand as still as a statue before suddenly striking down with lightning speed, coming up with a fish or mammal in its long beak. After a day of hunting, herons fly back to their roost with long, slow wing beats, necks bent back into an **S** shape and long legs trailing behind. –VC

Cattle Egret

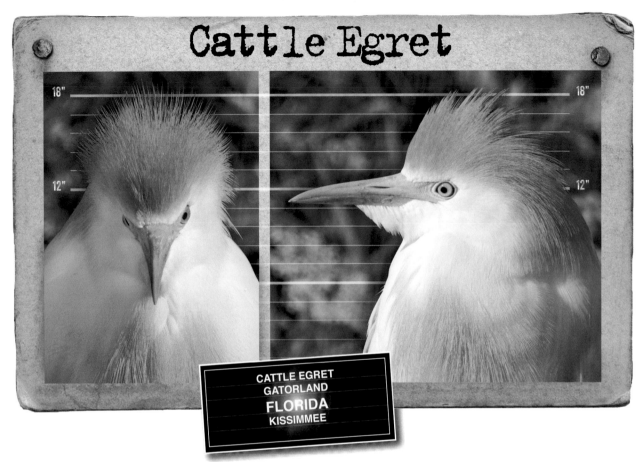

CATTLE EGRET
GATORLAND
FLORIDA
KISSIMMEE

MUG SHOT: The breeding plumage of this Cattle Egret features pale orange patches of feathers on its head and chest. During the non-breeding season, the bird will be all white. The bird's crest is raised in the side view. The side view shows that the Cattle Egret can tuck its neck in so it almost disappears. The front view emphasizes its long, sharply pointed beak. Feathers growing under the beak, and bare skin around its eyes, are also visible in the side view. –EO

NATURAL HISTORY: A small white bird standing in a field of cows or horses invariably is a Cattle Egret, sometimes perching on the back of livestock to eat flies. This small heron emigrated from Africa to this hemisphere more than a century ago, reaching the southern United States in the 1950s. The buffy orange crown, back and chest are its breeding plumage. Not as tied to water as others in its family, the Cattle Egret forages for grasshoppers, frogs, mice, songbird eggs and many other kinds of small prey in pastures and fields. Their dietary flexibility has made them one of the most abundant herons in North America. –VC

24

Snowy Egret

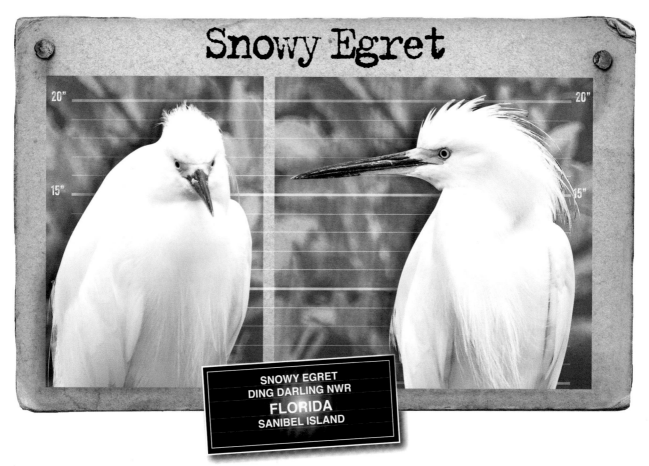

SNOWY EGRET
DING DARLING NWR
FLORIDA
SANIBEL ISLAND

MUG SHOT: Egrets and herons have long necks but they can tuck them in so that the neck, and even the head, seem to disappear. That is certainly how it looks in the front view of this bird. The sharpness of its dagger-like beak is clearly emphasized in the front view. The side view shows that feathers under the beak extend out to about half the length of the beak. Also notice the bare yellow skin that is around the eyes and extends to the edge of the beak. –EO

NATURAL HISTORY: This small, elegant wading bird, with its black beak, all-white feathering and its standout yellow feet, is a familiar sight to people who take winter vacations along the Gulf Coast. Its "golden slippers" are often hidden by water as these egrets stand, walk or run along coastal wetlands or riverbanks in search of food. They'll stir the water with a foot to make fish, frogs, worms, crustaceans and insects easier to snap up in that long beak. Snowy Egrets were hunted almost to extinction to provide plumes for women's hats in the 19th century, before they were protected by federal and state laws. –VC

Least Bittern

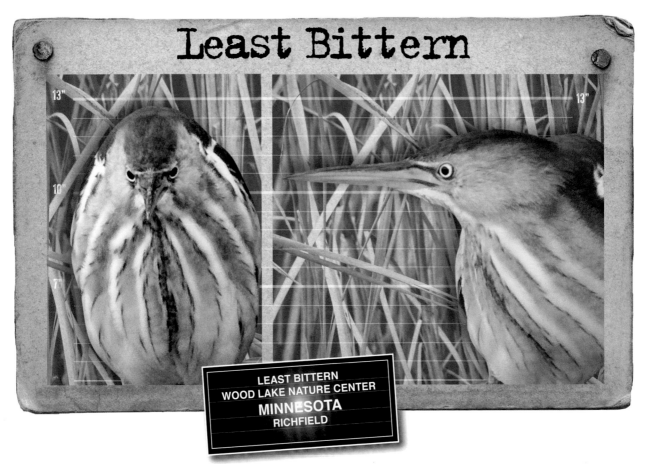

LEAST BITTERN
WOOD LAKE NATURE CENTER
MINNESOTA
RICHFIELD

MUG SHOT: The Least Bittern is a small bird but has a relatively large beak. The front view makes both the beak and the head look really tiny. This bird spends a lot of time in cattails so its alternating tan and white stripes provide good camouflage. Plumage features like these stripes help to hide a bird by breaking up its outline against the background. If the Least Bittern stands very still in a cattail marsh, it blends right in. –EO

NATURAL HISTORY: This small wading bird spends its time in freshwater or brackish marshes, stalking small fish and dragonflies, as well as tiny frogs and snakes. It's a challenge to spot as it skulks through tall, dense reeds and cattails, its narrow body allowing it to slip through easily. Although not very tall, they have an unusual habit that allows them to hunt over fairly deep water: Least Bitterns grasp reed stalks with their long toes and curved claws, perching motionless as they wait for prey to pass by, suddenly jabbing at it on the water's surface. Most of us only spot this bird as it flies away. –VC

Virginia Rail

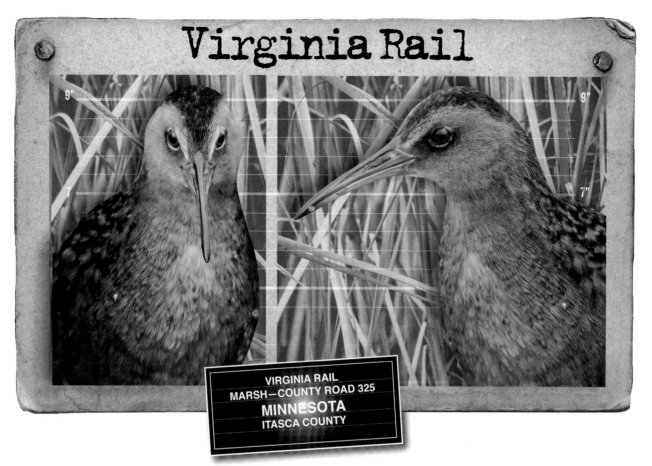

VIRGINIA RAIL
MARSH—COUNTY ROAD 325
MINNESOTA
ITASCA COUNTY

MUG SHOT: From the front, the face of this Virginia Rail makes me think of an owl because it seems to have facial discs surrounding its eyes. Looking at the side view, you would probably say it has an orange beak. However, the front view makes it obvious that the upper mandible is mostly gray. The front view shows that the beak is quite thin. (We might say it is "thin as a rail.") It also shows that the beak flares out at the base, something not visible from the side. –EO

NATURAL HISTORY: Thin beak, thin body, this secretive marsh bird seems to wear a cloak of invisibility. Somewhat smaller than a robin, its leanness allows it to squeeze easily through the dense cattails and reeds that make up its marshy habitat. The rail's long beak is ideally suited to probe mud and vegetation for the insects, snails and other invertebrates, as well as fish, frogs and small snakes that make up its diet. Those who'd like to see this bird are frequently frustrated because it's an ideal skulker, but its presence may be signaled by movement within the marsh reeds or its distinctive *kidick, kidick* call. –VC

Ruddy Turnstone

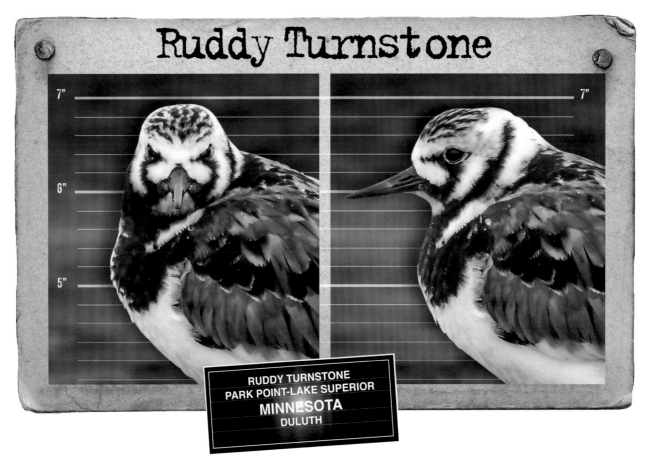

RUDDY TURNSTONE
PARK POINT-LAKE SUPERIOR
MINNESOTA
DULUTH

MUG SHOT: It was a pleasant surprise to find this male Ruddy Turnstone while birding in Duluth, Minnesota. My only chance of seeing one in breeding plumage in Minnesota is during migration, and not many of them stop here. I happened to be in the right place at the right time. This bird looks very stern from the front. However, all those black stripes serve as camouflage when the Ruddy Turnstone is on its breeding territory in the far northern Arctic. –EO

NATURAL HISTORY: No, he's not trying out for an "angry bird" award. The dark facial markings during breeding season can seem to suggest a dark mood, but in reality a turnstone is intent only on finding things, including insects, to eat. Turnstones have their own feeding niche along crowded coastlines: Aptly named for their unique feeding style, these birds skitter along beaches, mudflats and jetties, pecking and probing around stones, sticks and algae, continually turning things over to find what's underneath. They sometimes even work together to flip larger objects. Their beaks are short but fairly thick, serving as levers to get to their prey. –VC

Black Oystercatcher

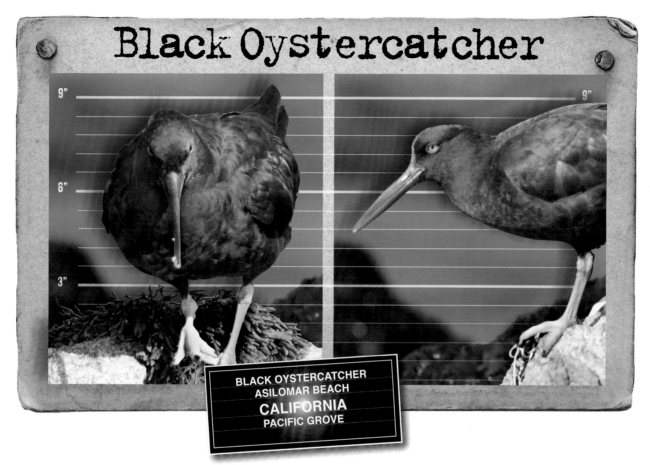

BLACK OYSTERCATCHER
ASILOMAR BEACH
CALIFORNIA
PACIFIC GROVE

MUG SHOT: A Black Oystercatcher, with its black and brown plumage, is often well hidden among the dark rocks of the Pacific shore, but its bright orange-red beak and its pale pink legs are hard to miss. The front view shows that the beak is thin but becomes wider at the base. This long, pointed beak is useful for prying open the shells of the mollusks that it feeds on. The side view shows the oystercatcher's yellow eye and orange-red eye ring. –EO

NATURAL HISTORY: A large, dark bird seen stalking along a rocky shore from Alaska to Baja California on the Pacific Coast is usually a Black Oystercatcher. Conspicuous and noisy, these shorebirds stalk, head down, at low tide, searching primarily for mussels and limpets, as well as whelks and crabs. Their beaks are ideal for forcing apart mussel shells or beating them open. Oystercatchers tend to rest during high tide and despite their name, they don't consume many oysters. Black Oystercatchers fly upward when disturbed, emitting their loud, piping call. They're non-migratory, and because of this, their preferred habitats are vulnerable to oil spills. –VC

Royal Tern

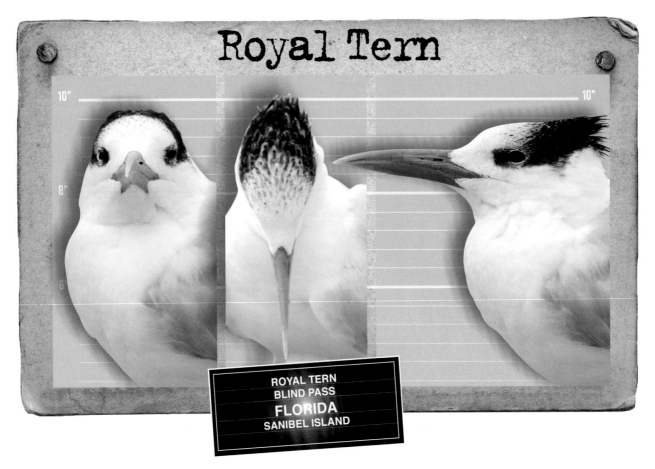

ROYAL TERN
BLIND PASS
FLORIDA
SANIBEL ISLAND

MUG SHOT: The front view makes it look like the tern is wearing a tiny black cap. The other two photos show that the black feathers actually extend from the middle of its head to the back of its head. This bird is in non-breeding plumage. During the breeding season, the entire top of its head will be black. The front view makes the beak look like a five-pointed star and gives no indication of how long it really is. The other two photos reveal that the beak is long and dagger-like. –EO

NATURAL HISTORY: Royal Terns are among the largest members of the tern family, measuring about 20 inches from beak to tail. Like all terns, they have an elegant flight style, sweeping through the air on strong wing beats. Royal Terns forage by hovering over the water with beak down, and then plunge diving to catch prey near the surface. They sometimes fly low with their beak in the water. Their diet is predominantly small fish, but also includes crabs, shrimp and squid. These terns inhabit coastlines, especially the southern Atlantic and Gulf Coasts. During nesting season they gather in huge island colonies, each pair caring for a single chick. –VC

Ring-billed Gull

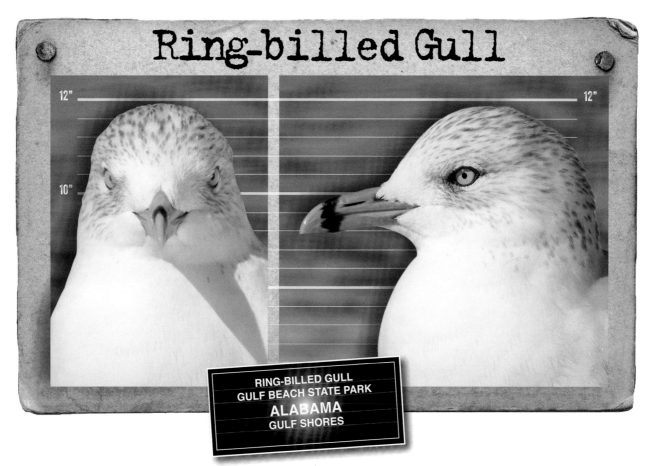

12"

10"

12"

RING-BILLED GULL
GULF BEACH STATE PARK
ALABAMA
GULF SHORES

MUG SHOT: The side view confirms that the Ring-billed Gull is appropriately named. In the front view, the dark ring on the beak is just barely visible. Also in the front view, the beak looks surprisingly thin, except for the base, which looks like a five-pointed yellow star. Dark streaks on the head of this bird indicate non-breeding plumage. After it molts to breeding plumage, the head will be completely white. The side view shows a thin, red ring around the eye. –EO

NATURAL HISTORY: A white bird perched on a light pole over a parking lot, avidly waiting for food scraps to be tossed, invariably is a Ring-billed Gull. In fact, they're known as "fast food gulls," for their habit of scavenging for morsels around restaurants and malls. Found just as often around inland lakes and rivers as in coastal areas, they're always on the lookout for food. They're not picky, and will eat insects, fish, worms and rodents, as well as refuse at landfills. Most of their time is spent feeding on land, but they also forage by swimming or wading, or flying after insects. –VC

Atlantic Puffin

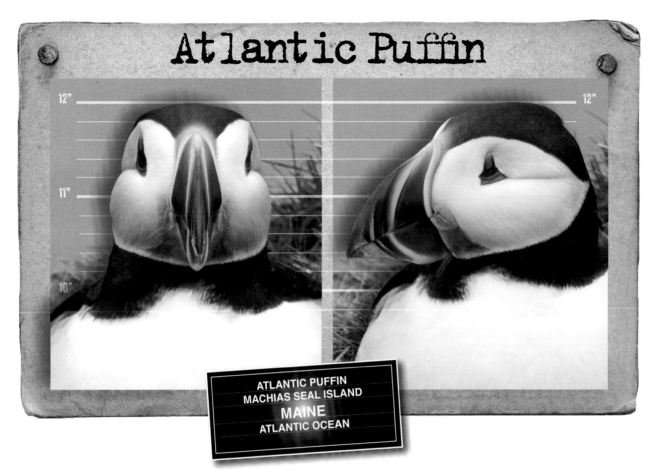

12"

11"

10"

12"

ATLANTIC PUFFIN
MACHIAS SEAL ISLAND
MAINE
ATLANTIC OCEAN

MUG SHOT: People who visit Machias Seal Island sit in wooden blinds so the birds are not disturbed. Puffins go about their business as close as 6 feet away. One landed right in front of me and stared straight at the camera. It turned its head from side to side, providing the perfect mug shots. The side view gives the impression that the spectacular bill is massive. The front view, however, reveals that it is quite thin. The dark lines above and behind the eyes give the puffin an alert, quizzical look. –EO

NATURAL HISTORY: The Atlantic Puffin, sometimes called a "sea parrot," is known primarily for its colorful, oversized bill. When these small, stocky birds are viewed head-on, their deep-set eyes and chubby cheeks stand out. An adult hunts food underwater, with up to 10 fish at a time hanging from its beak, before returning to the burrow to feed its chick. Once breeding season is completed, puffins shed some of their beak's colorful plates, looking so different between summer and winter they were once thought to be two separate species. These are very endearing birds as they bob on the ocean or loaf on their breeding grounds. –VC

Razorbill

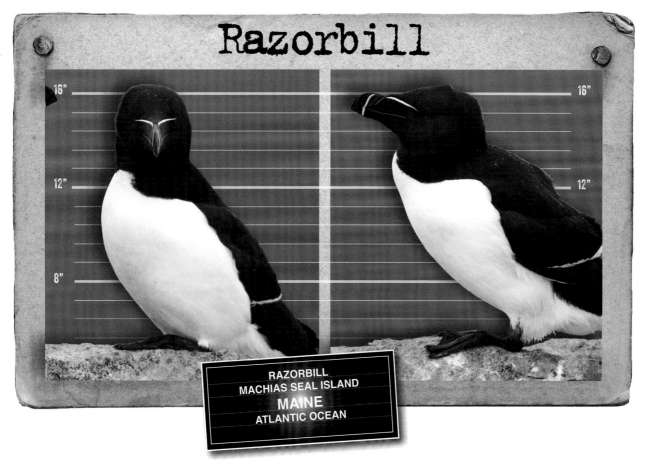

RAZORBILL
MACHIAS SEAL ISLAND
MAINE
ATLANTIC OCEAN

MUG SHOT: The Razorbill's plumage is about half white and half black. The black part is interrupted by thin white lines in several places: on the edge of each wing, in a ring around the beak and from the beak to each hard-to-see eye. The beak looks large in the side view but the front view shows it to be very thin. The front view is disorienting because those thin white lines look like they should be the eyes of this bird. –EO

NATURAL HISTORY: Razorbills spend most of their lives offshore on open water in the northern Atlantic, making them a bird that few of us have seen. These duck-sized diving birds pursue fish, shrimp and squid by "flying" underwater with wings outstretched to catch their prey. During the summer breeding season, Razorbills are found in large groups, called colonies, on islands or along the coast. They raise a single chick in a nest formed by a shallow bowl of pebbles among boulders, or in rock cracks or caves. These birds winter in large flocks offshore but may be seen along coastlines during storms. –VC

Harris's Hawk

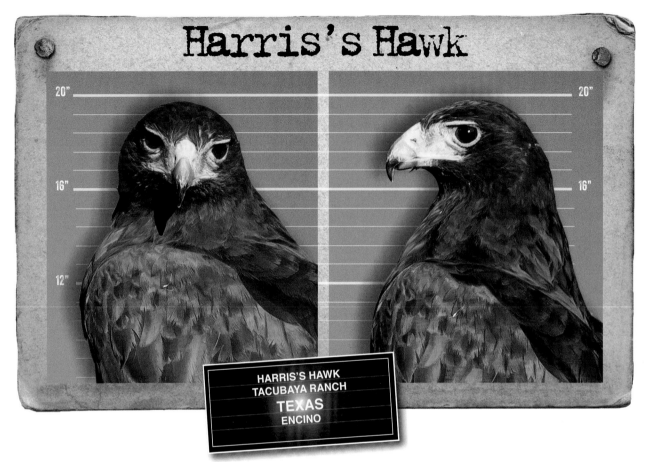

**HARRIS'S HAWK
TACUBAYA RANCH
TEXAS
ENCINO**

MUG SHOT: This Harris's Hawk has a typical large and powerful raptor beak. The side view shows three distinct sections of the beak. At the base of the beak, behind the upper mandible, is a fleshy area called the cere (pronounced "sear"). The middle part of the beak is light blue and the hooked tip is black. The side view shows a patch of bare skin between the eyes and the beak. Both views show a thin strip of bare skin surrounding the eyes. –EO

NATURAL HISTORY: Several behaviors of this beautiful hawk make it a standout among raptors. They're the most social of hawks, often hunting together in small groups, with one bird flushing a rabbit or desert rat, the others chasing it down, then taking turns eating. And, in their desert-like habitats, perches are often scarce, so Harris's Hawks can sometimes be found "back stacking," with up to four birds standing on each other's backs on a utility pole or tree to get a good view of the countryside. They're agile flyers, a pleasure to watch in flight, but they also hunt by running on the ground. –VC

Cooper's Hawk

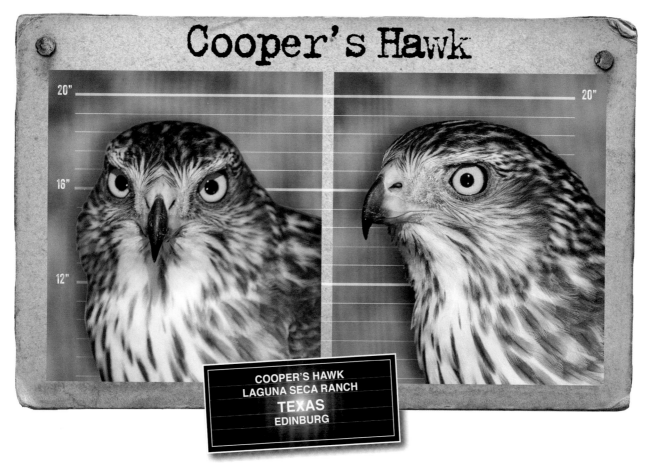

20"
16"
12"

20"

COOPER'S HAWK
LAGUNA SECA RANCH
TEXAS
EDINBURG

MUG SHOT: The side view of this Cooper's Hawk shows a hook at the end of its beak. The hook is a formidable tool for making a swift kill of the birds it preys on. It also aids in tearing captured prey into smaller pieces. Both eyes of this bird are quite visible in the front view. This is true of many species that hunt other animals for food. Having the eyes pointing toward the front gives them better binocular vision and aids in accurately catching their prey. –EO

NATURAL HISTORY: Cooper's Hawks specialize in preying on birds, including Mourning Doves, starlings, pigeons, robins and jays. They're agile and skillful fliers, built to turn and weave easily through dense vegetation in pursuit of a terrified bird. Careening through forests, these hawks often suffer collisions with tree limbs, with about a quarter of them in one study showing healed broken chest bones. They catch a bird (or small mammal) with their talons, then pluck and eat it near the kill site. These hawks sometimes learn to hunt at urban or suburban bird feeders for an easy meal. Females are crow-sized but males are only about two-thirds as big. –VC

Snail Kite JUVENILE

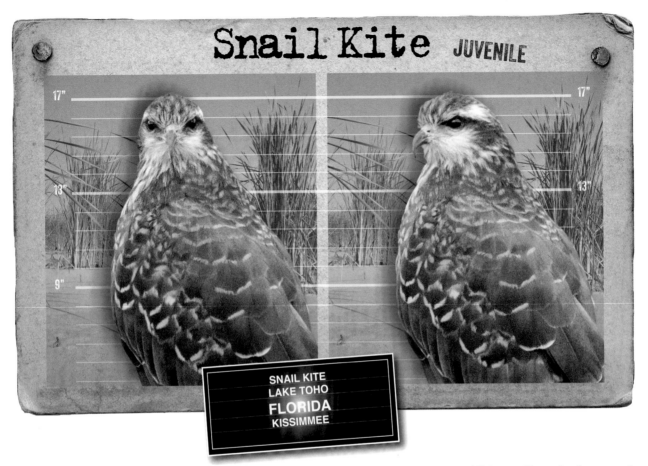

SNAIL KITE
LAKE TOHO
FLORIDA
KISSIMMEE

MUG SHOT: The side view of this Snail Kite reveals a strongly hooked, raptor-like beak, but it is comparatively small and slender. That's because it has a different purpose than the beaks of other raptors. As its name implies, this kite eats snails and its thin beak is perfect for reaching into a shell and extracting the snail. The forward-looking eyes of a predator are evident in the front view. The nostrils are located in the fleshy base of the upper mandible. –EO

NATURAL HISTORY: This medium-sized raptor is found in the United States only in central and south Florida, where it enjoys one of the most specialized diets among birds of prey. All raptors have hooked beaks but this hawk's is especially adapted to scoop the meat out of snail shells. Their almost total reliance on apple snails has led to this kite's listing as an endangered species: The snails are disappearing due to their freshwater marsh habitat being degraded or lost to development in Florida. Snail Kites are a joy to watch as they fly low and slow over a wetland, head down and on alert for snails on or below the water's surface. –VC

Crested Caracara

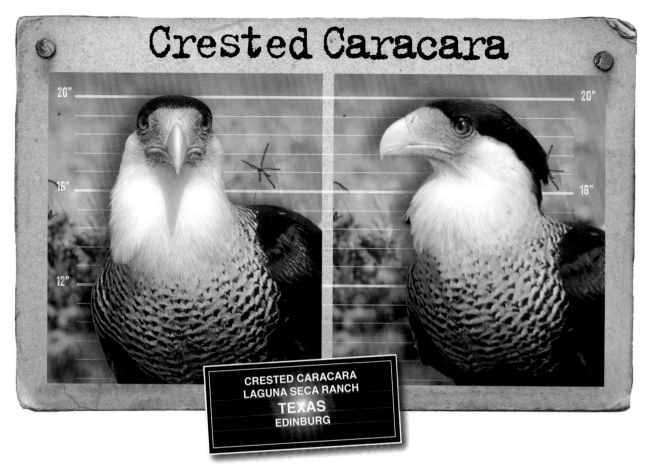

CRESTED CARACARA
LAGUNA SECA RANCH
TEXAS
EDINBURG

MUG SHOT: The side view of this Crested Caracara reveals its large, strong beak. This bird is a scavenger and that formidable beak allows it to tear chunks of meat from a carcass. The bird's bare facial skin extends all the way back behind its eyes. With no feathers in this area, the caracara has an easier time keeping itself clean after feasting on road-kill. The front view shows that the light blue tip of the beak is narrow but the rest of the beak is tapered and gets wider at the base. –EO

NATURAL HISTORY: Caracaras are about the size of a Red-tailed Hawk with very long legs. Unlike most raptors, roadkill and other carrion make up a large part of its diet, but it also catches small rodents, lizards, snakes and insects. A caracara will watch for vultures flying down to a carcass, often driving the larger birds away to feed alone. They're also known to fly in front of prairie fires or behind a plow, catching small animals fleeing the disturbance. Crested Caracaras are a familiar sight in southeastern Texas along roadsides, fence posts or utility poles. –VC

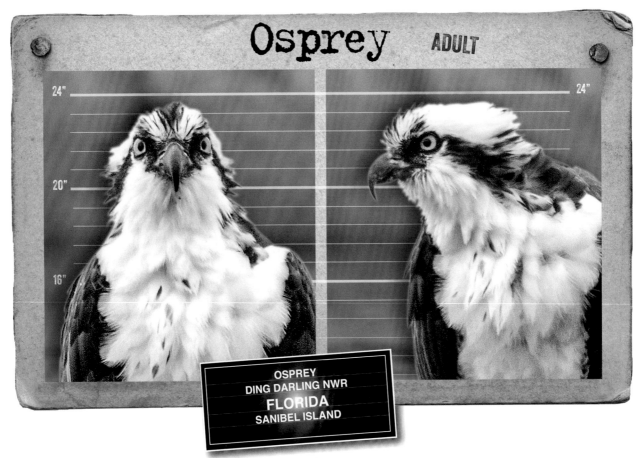

OSPREY
DING DARLING NWR
FLORIDA
SANIBEL ISLAND

MUG SHOT: The Osprey is strictly a fish eater so its beak has a slightly different shape than the beaks of other raptors. It has a strong, thick base and a wicked looking hook on the end for tearing fish into smaller pieces. The beak is not involved in the capture of a fish; that function is performed by its powerful talons. The brown stripe down the middle of the Osprey's head is only revealed when you look at the front view. –EO

NATURAL HISTORY: Osprey are known as the fishing hawks, with fish making up nearly their entire diet. They fly over shallow waters, sometimes hover briefly, and then dive into the water, feet first, to snatch a fish. They're good at their job, coming up with a catch about one out of every four tries. Osprey are enjoying a comeback in many areas, thanks to the 1972 ban on the pesticide DDT and the erection of many human-made nesting platforms along shorelines. With a crook in their long narrow wings forming an **M** shape in the air, they're sometimes (briefly) mistaken for gulls. –VC

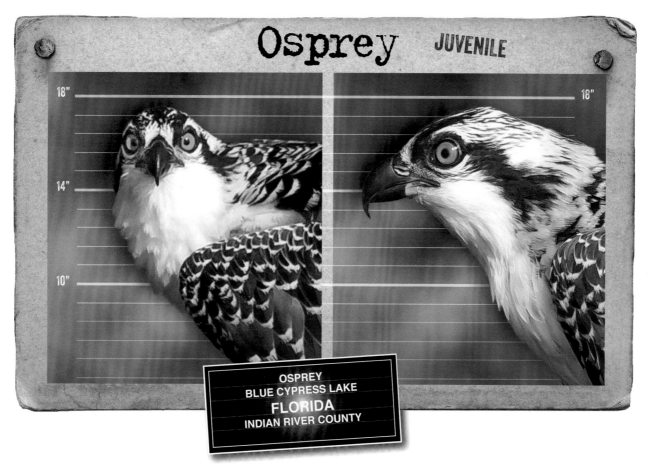

Osprey JUVENILE

OSPREY
BLUE CYPRESS LAKE
FLORIDA
INDIAN RIVER COUNTY

MUG SHOT: At a photography workshop on Blue Cypress Lake in central Florida, we maneuvered our boat along the shore, weaving in and out among the living and dead cypress trees. There were hundreds of Osprey nests built in these trees. One nest was at eye level, giving us fabulous looks at the juvenile Osprey inside. The crisp white tips of this bird's brand-new feathers will eventually wear off and it will then look more like the adult Osprey. The juvenile has bright orange eyes, which will gradually change to yellow as it matures. –EO

American Kestrel MALE

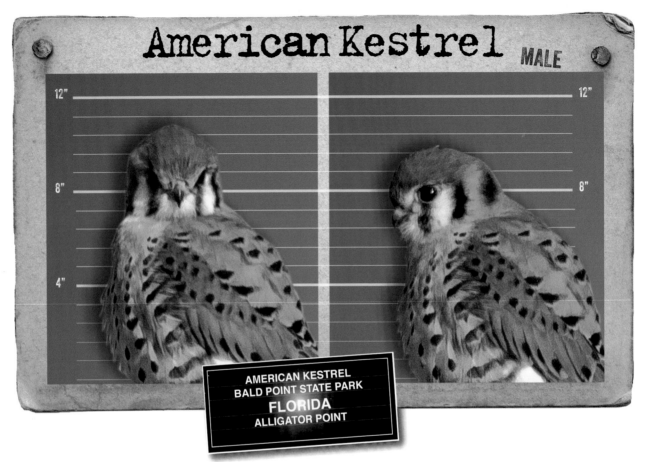

12"

8"

4"

12"

8"

AMERICAN KESTREL
BALD POINT STATE PARK
FLORIDA
ALLIGATOR POINT

MUG SHOT: The kestrel's raptor-type beak is very tiny but it does have a sharp, hooked tip. It doesn't need a large beak because it eats mostly insects and small mammals. The vertical black streaks extending down from its eyes are reminiscent of the horizontal black stripes under the eyes of baseball and football players. Presumably, they serve the same purpose, to help cut down the glare from the sun. Both views show a rusty patch of feathers on top of the head. –EO

NATURAL HISTORY: The American Kestrel is not much bigger than a cardinal. But don't be fooled by its small size: it is an intense predator, spending its days hunting over open fields, parkland and meadows in search of grasshoppers, other insects, small rodents or even a small bird. Kestrels often perch on utility lines or fence posts, and may be mistaken for Mourning Doves, until their frequent tail wags and stocky shape clarifies the identification. With their population dropping alarmingly in some areas, humans are putting up nest boxes in attempts to help them recover. –VC

Peregrine Falcon

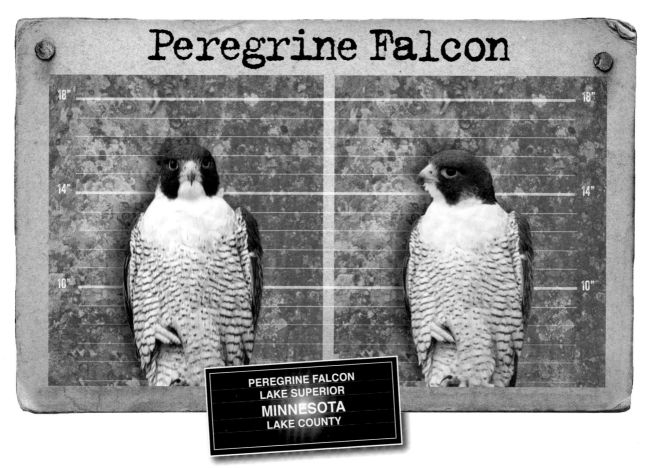

PEREGRINE FALCON
LAKE SUPERIOR
MINNESOTA
LAKE COUNTY

MUG SHOT: I had the chance to photograph this Peregrine Falcon on a Lake Superior boat cruise in northern Minnesota. The rocky shoreline near Split Rock Lighthouse is an ideal place for a peregrine to nest. The front view emphasizes the dark hood of the species. The three sections of its beak (yellow cere at the base, blue in the middle, black tip) are similar to those found on the Harris's Hawk. Also notice the featherless area surrounding the eyes. –EO

NATURAL HISTORY: This falcon is one of the fastest birds in the world, reaching speeds up to 67 miles per hour as it pursues its prey in level flight. But its most spectacular feat is the stoop, an aerial dive with wings tucked. It may plummet at speeds up to 235 miles per hour to knock a bird out of the air. Once seriously endangered by pesticides, the ban on DDT in conjunction with other human efforts are aiding this raptor's recovery. Many peregrines now build their nests on skyscraper ledges and feast on a city's abundant Rock Pigeons. –VC

Bald Eagle

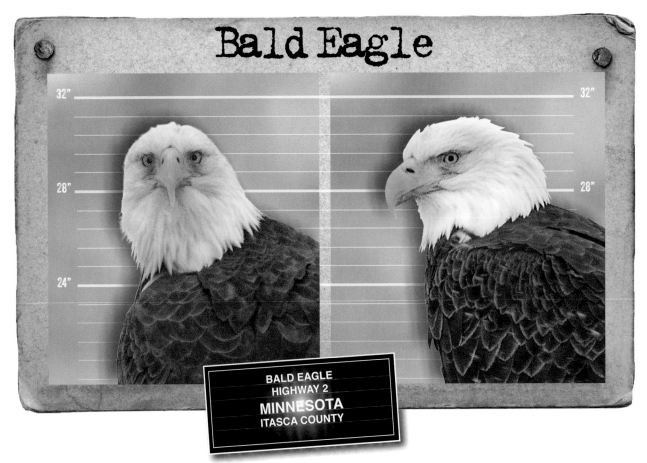

BALD EAGLE
HIGHWAY 2
MINNESOTA
ITASCA COUNTY

MUG SHOT: The side view of this Bald Eagle, our national bird, presents a strong and powerful image. But the front view is not nearly as flattering. (Actually, the front view is a back view: The bird is facing away from the camera but has its head turned a full 180 degrees.)

The Bald Eagle has a large, impressive beak with a big hook on the end. It needs a strong beak for tearing its food into small pieces. The beak is all yellow so it is easy to miss the cere of this bird where the nostrils are located. –EO

NATURAL HISTORY: Look for Bald Eagles near water, such as lakes, rivers, reservoirs or coastlines, as they hunt for fish. But these regal raptors also are scavengers, often harassing other birds, especially Osprey, for their catch. In winter, eagles often feed on carrion or roadkill but may congregate by the hundreds around open water, standing on ice to pull fish out of the water or chipping "fishsicles" out of the ice. Their huge nests are hard to miss, added to year after year by the same pair. Once endangered, the ban on the pesticide DDT in the early 1970s has helped this impressive raptor recover. –VC

42

Short-eared Owl

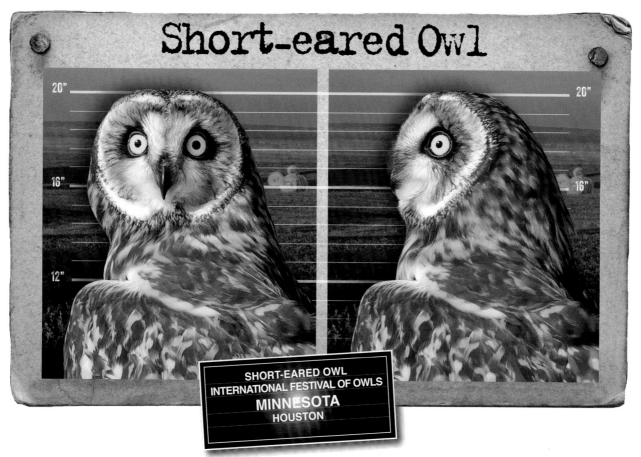

SHORT-EARED OWL
INTERNATIONAL FESTIVAL OF OWLS
MINNESOTA
HOUSTON

MUG SHOT: The feathers on an owl's face are shaped into a disc so they funnel sound to the owl's ears, which are located near the eyes. The side view of the Short-eared Owl reveals a deep facial disc that helps it hear even the quietest of sounds made by potential prey. The front view shows that the facial disc is outlined by a ring of white feathers. Large eyes help it see in low light. The relatively small beak is used primarily for tearing prey into smaller pieces. –EO

NATURAL HISTORY: This handsome medium-sized owl differs from most of its relatives in several key ways. For one, it's fairly easy to spot as it hunts in open country, often in daylight or at dusk. For another, it nests on the ground, instead of in trees. And its flight style, with floppy wing beats, has been called mothlike. Short-eared Owls are a pleasure to watch as they crisscross a field, flying low and listening for the sounds of a vole or mouse scurrying along below. They're named for their short ear tufts, which are seldom visible unless the owl is being aggressive. –VC

Great Gray Owl

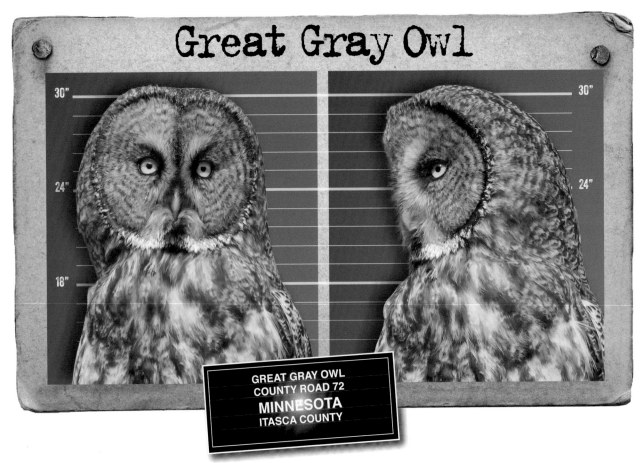

GREAT GRAY OWL
COUNTY ROAD 72
MINNESOTA
ITASCA COUNTY

MUG SHOT: The Great Gray Owl presents a tidy, well-groomed look. The front view shows a well-defined facial disc surrounded by a thin ring of feathers. The side view reveals the facial disc to be about half the depth of its head. The feathers on the back of its head form a smooth contour and make the bird look like it's wearing a tight-fitting hooded sweatshirt. I was birding along a rural road when this bird suddenly flew in and landed in a tree directly above me. It paid no attention to me. –EO

NATURAL HISTORY: This massive-looking owl wears a thick feather coat to survive life in the boreal forest, but underneath is a lightweight bird, averaging about 2½ pounds. Their prey is almost exclusively voles. The Great Gray Owl's ears sit asymmetrically, one higher than the other, resulting in superb hearing. Amazingly, they can detect prey moving under snow a football-field's distance away. They're powerful owls, able to plunge into hard packed snow, head and talons first, to snatch up a vole scurrying underneath. In the United States, the best chance to see one of these majestic owls is in a year when many move southward in search of food. –VC

Barred Owl

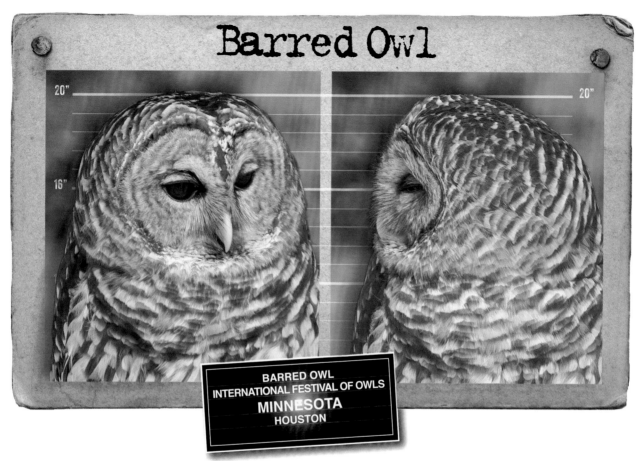

20"

16"

20"

BARRED OWL
INTERNATIONAL FESTIVAL OF OWLS
MINNESOTA
HOUSTON

MUG SHOT: Barred Owls do most of their hunting at night. They have amazing eyesight that helps them see in the dark. They also depend on very sensitive hearing to help locate their prey. The apple-shaped set of feathers surrounding their eyes is called a facial disk. It helps funnel sound to their ears to pinpoint prey and increase the success of their attacks. The side view of the Barred Owl shows that its facial disc is quite shallow, which is not obvious when looking at the front view. –EO

NATURAL HISTORY: This brown-eyed owl's short, curved beak all but disappears in the side view but its prey, including small mammals, young rabbits and insects, know how lethal it can be. The lower beak is hinged, allowing a Barred Owl to open wide to consume an entire mouse, and the beak's scissor-like properties can tear larger prey into digestible pieces. These medium-sized owls can frequently be heard hooting their haunting "*Who cooks for you, who cooks for YOU-all*" calls during the daytime and at night in dense forests. They are lightweight but appear heavier due to their dense feather coats. –VC

Eastern Screech-Owl

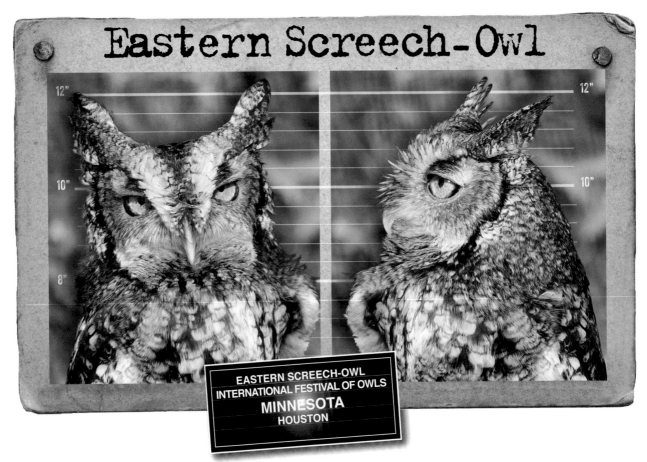

EASTERN SCREECH-OWL
INTERNATIONAL FESTIVAL OF OWLS
MINNESOTA
HOUSTON

MUG SHOT: The tufts of feathers on top of this Eastern Screech-Owl's head are not its ears. Bird experts don't know why some owls have ear tufts and others do not. They think it helps the owl blend in with its surroundings when roosting in a tree because the ear tufts might look like broken branches. The side view reveals a facial disc more than half the depth of the entire head. The front view features a prominent triangle of feathers from the ear tufts to the beak, giving the bird a somewhat cross-eyed look. –EO

NATURAL HISTORY: These small raptors are one of the least visible of the owls, their plumage providing perfect camouflage for blending in with the bark of the trees where they spend most of their time. Screech-Owls are most active after dark, so listen for their trills and whinnies at night in wooded areas. They'll eat just about anything that moves, including small mammals, birds, insects, fish, frogs and worms. Many of these owls are gray, but some have a reddish feather coat. On cold winter days this small owl might be spied sunning itself from inside the entrance to a wood duck box or tree hole. –VC

Great Horned Owl

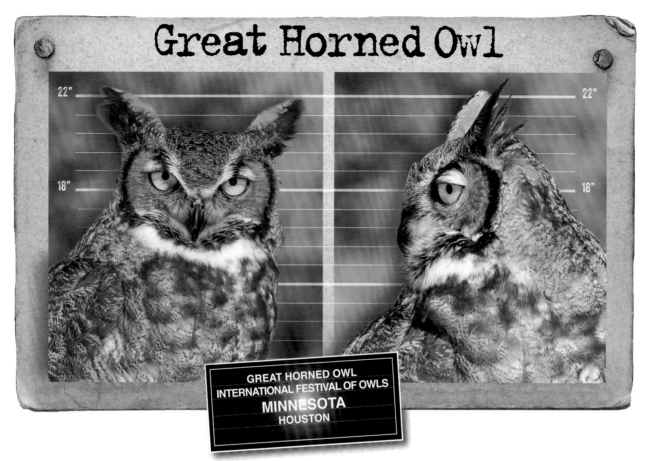

GREAT HORNED OWL
INTERNATIONAL FESTIVAL OF OWLS
MINNESOTA
HOUSTON

MUG SHOT: The Great Horned Owl is another owl with tufts of feathers on top of its head. These are sometimes mistakenly identified as the bird's ears. The ears are actually located near the eyes, within the ring of black feathers that defines the edge of the facial disc. This allows the facial disc to funnel sound to the ears. The side view shows that the facial disc is about half the depth of the entire head. The massive feet and talons of this bird are formidable weapons. –EO

NATURAL HISTORY: Great Horned Owls are powerful predators, so fierce that they've earned the nickname, "flying tigers." They prey on everything from small rodents, to muskrats and skunks, to large birds like Osprey and Peregrine Falcons. This is the bird most of us think of when we think of an owl, with its large, intimidating eyes, deep, hooting calls and massive body. The eyes take up about a third of the space in the brain, so they may not be quite as wise as folklore has it. These owls will nest in the same area for years, using cliffs, snags and living trees, often adopting old nests built by Red-tailed Hawks, crows, ravens or squirrels. –VC

Spruce Grouse

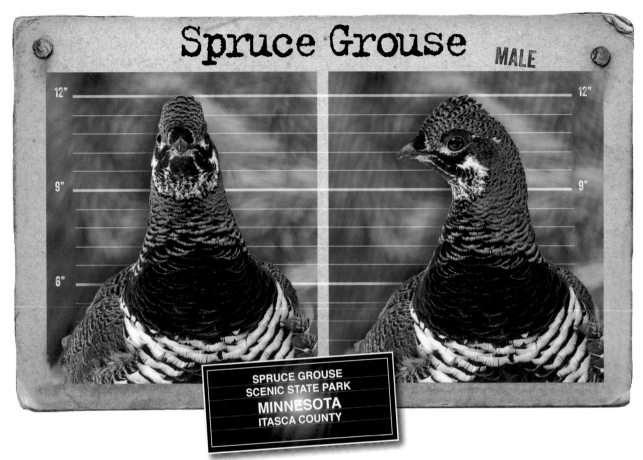

12"
9"
6"
12"
9"

**SPRUCE GROUSE
SCENIC STATE PARK
MINNESOTA
ITASCA COUNTY**

MUG SHOT: This male Spruce Grouse has a patch of bare red skin, called a comb, above each eye. It is scarcely visible in the front view, but the side view reveals the full extent of this bright eye decoration. He has a very short beak. In the front view, note the position of the eyes, pointed more to the side than forward. Grouse are hunted by humans and other predators and need to be aware of threats from all directions. The side-oriented placement of his eyes gives him an edge in spotting danger. –EO

NATURAL HISTORY: Inhabiting dense coniferous forests in the northern United States, Alaska and Canada, these stocky, chicken-like birds are fairly inconspicuous and easy to overlook as they feed quietly in trees. Males create dramatic courtship displays to attract females by fanning and swishing their tail feathers and puffing up their red "eyebrows," then performing short, vertical "flutter flights" on stiff wings. True to their name, these grouse feed on spruce and pine needles in winter, adding tamarack needles, green shoots, berries and insects in summer. They seem unafraid, almost tame, around humans. –VC

48

Ruffed Grouse

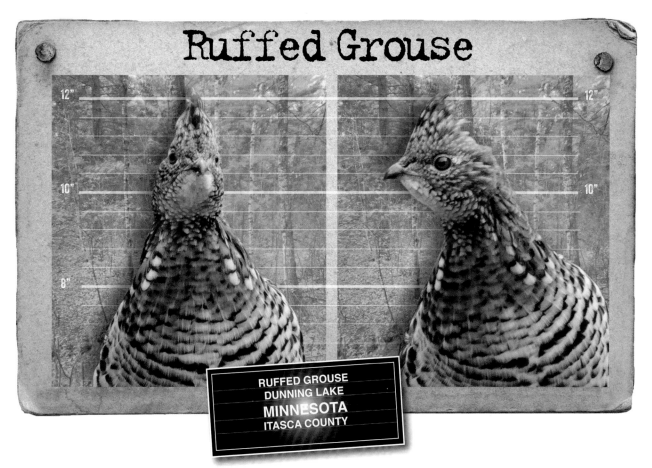

RUFFED GROUSE
DUNNING LAKE
MINNESOTA
ITASCA COUNTY

MUG SHOT: This Ruffed Grouse has its head feathers raised, giving it a crest similar to that of a Northern Cardinal. In the front view, the raised crest makes the bird's head look cone-shaped. The stubby beak almost disappears in the front view and the white chin feathers are more visible in the front view than in the side view. The neck feathers are long and can be raised to form a puffy circle that looks like a ruff, hence the name Ruffed Grouse. –EO

NATURAL HISTORY: Ruffed Grouse are secretive birds and difficult to see, with their camouflaging feathers and habit of living deep within the forest. Their standout feature is their use of sound, called drumming: A male bird stands on a log or mound of dirt and rotates his wings back and forth at high speed. This creates a vacuum under the wings, generating a deep thumping sound that can be heard a quarter mile away. People who hear this deep vibration for the first time often mistake it for a tractor starting up. Ruffed Grouse drum all year long, but intensify their sound making in springtime, to attract a mate. –VC

Greater Roadrunner

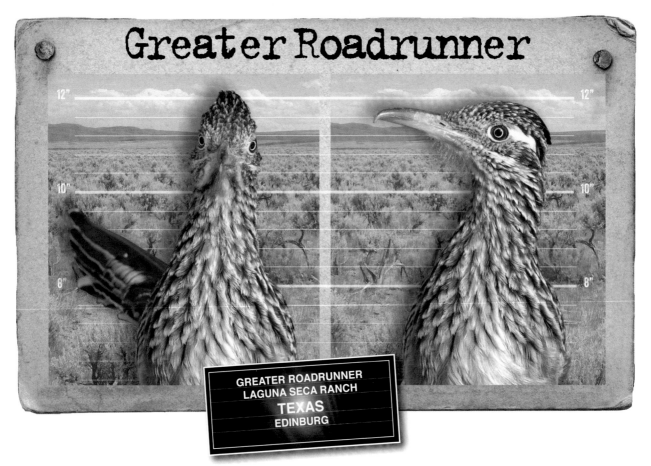

GREATER ROADRUNNER
LAGUNA SECA RANCH
TEXAS
EDINBURG

MUG SHOT: The Greater Roadrunner's thin, moderately long beak is obvious in the side view but insignificant when viewed from the front. The side view shows a sharp hook at the end of the upper mandible, useful for securely holding its squirming prey. The side view also shows a thin, white eye ring and a patch of bare white skin behind the eye. Many hair-like bristles protrude below the beak. The longer feathers on top of the head can be raised to form a crest. –EO

NATURAL HISTORY: They can outrace a human, kill a rattlesnake and survive harsh, desert environments (they can't, however, outrun a coyote, unlike their cartoon counterpart). Greater Roadrunners eat just about anything, including small mammals, snakes, lizards, frogs, toads, insects and scorpions. They race along roads, trails and streambeds, defending their large territories, and two will often work together to kill a rattlesnake: One roadrunner will distract the venomous snake while the other pins down its head. Better runners than fliers, they can be seen along quiet roads in open country. –VC

Ruby-throated Hummingbird

MALE

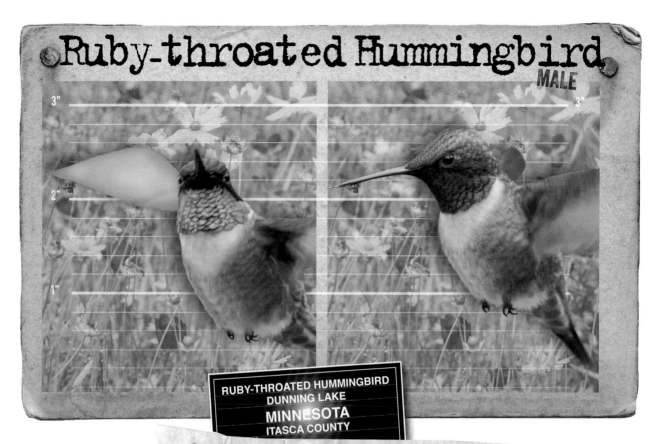

3" 3"

2"

1"

RUBY-THROATED HUMMINGBIRD
DUNNING LAKE
MINNESOTA
ITASCA COUNTY

WHAT DO YOU SEE?

Enter your own observations below

Green Kingfisher

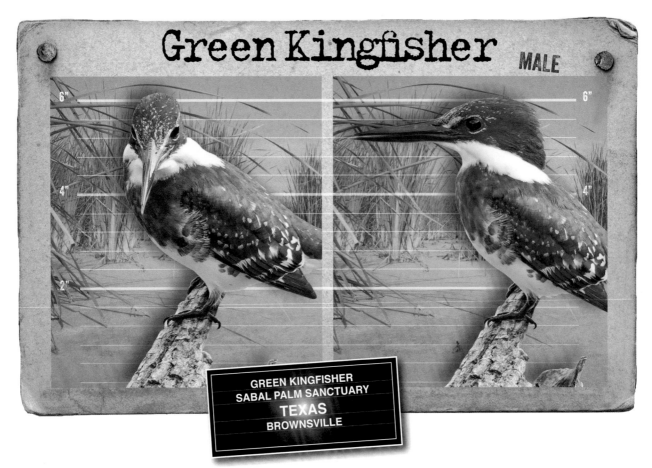

GREEN KINGFISHER
SABAL PALM SANCTUARY
TEXAS
BROWNSVILLE

MUG SHOT: The beak of a Green Kingfisher looks much too long to match the rest of its body. In the front view, however, the full length of the beak is much less apparent. The broad, rufous band across the chest indicates this is a male. The front part of his head is speckled with white dots and there are thin half-circles of white feathers above and below his eyes. The thin white stripes of feathers in front of the eyes are more noticeable in the front view. –EO

NATURAL HISTORY: They're the smallest kingfisher in the United States, and in reality are a tropical bird, but have established a population in south Texas and southeastern Arizona. They're tough to spot as they perch for lengthy periods on a branch low over the water, waiting for small fish, shrimp or aquatic insects to appear. When prey is in sight, the Green Kingfisher dives headfirst into the water, often returning to its previous perch to eat it. They're always found near water, and favor clear rivers and streams. When on the move, this small kingfisher flies fast and low over the water. –VC

Yellow-bellied Sapsucker

MALE

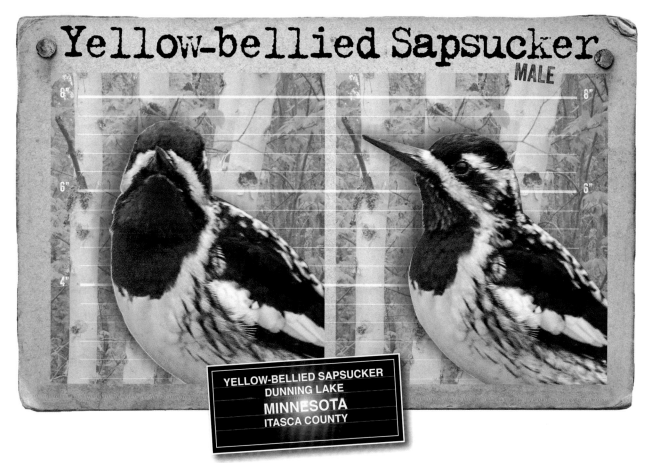

YELLOW-BELLIED SAPSUCKER
DUNNING LAKE
MINNESOTA
ITASCA COUNTY

MUG SHOT: These photos clearly show the yellow belly of a Yellow-bellied Sapsucker. This is an adult male; a female is similar, except her throat is white instead of red. A black band encloses the sapsucker's eyes, which almost disappear in the front view. The front view gives the impression of a bird with many patches of color: red, white, black and yellow. Like other members of the woodpecker family, the Yellow-bellied Sapsucker has a sturdy, sharply pointed beak. –EO

NATURAL HISTORY: If you notice horizontal rows of holes in the bark of a tree's trunk in Eastern North America, they're doubtless the work of a Yellow-bellied Sapsucker. This unusual woodpecker drills these holes to release sap, a major portion of its diet. Other wild creatures are drawn to these sap wells, including butterflies, squirrels and especially Ruby-throated Hummingbirds, which rely on them in early spring before flowers are available for nectar. Like other woodpeckers, sapsuckers add insects, seeds and fruit to their diet. Listen for their catlike mewing, since they're fairly difficult to spot. –VC

Downy Woodpecker

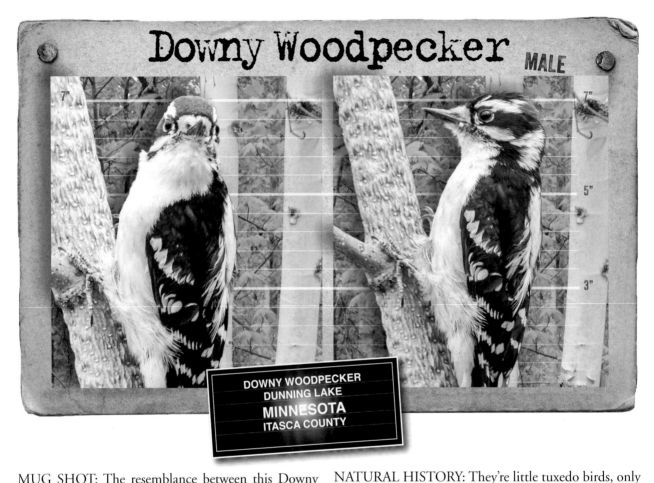

7"

7"

5"

3"

DOWNY WOODPECKER
DUNNING LAKE
MINNESOTA
ITASCA COUNTY

MUG SHOT: The resemblance between this Downy Woodpecker and its relative, the Hairy Woodpecker, is remarkable. Their black and white feather patterns are similar but the Downy Woodpecker is noticeably smaller than the Hairy Woodpecker and has a much shorter beak relative to its head size. The red patch on the back of its head identifies this bird as a male. In the front view, you can't see the red spot so you can't tell if it is a male or female. –EO

NATURAL HISTORY: They're little tuxedo birds, only slightly larger than a House Sparrow, making them the smallest woodpeckers in North America. Their frequent visits to bird feeders offering suet, peanuts or sunflower seeds make them a familiar sight to most of us. They eat foods that larger woodpeckers can't reach, hunting for insects on small twigs and even hammering on plant galls to reach the fly larvae inside. In winter, downies join up with chickadees, nuthatches and other species to forage together in the woods. Like other woodpeckers they don't sing, instead hammering on resonant surfaces to announce a territory or attract a mate. –VC

Hairy Woodpecker

MALE

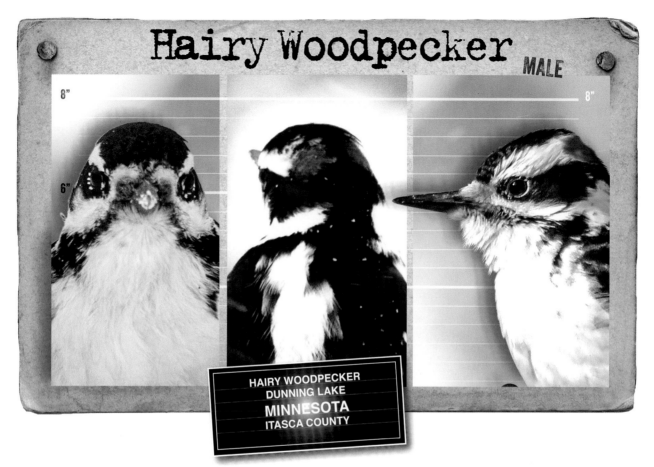

8"

6"

8"

**HAIRY WOODPECKER
DUNNING LAKE
MINNESOTA
ITASCA COUNTY**

MUG SHOT: The side view of this Hairy Woodpecker shows a relatively long, sturdy beak, useful for pounding holes in trees. The tuft of feathers at the base of the beak protects the bird's nostrils from flying chips of wood. Red feathers on the head indicate this is a male. The back view reveals that the red feathers on this bird form two spots and don't go across the entire head. The front view makes the bird look like it has a black cap, mask and mustache. –EO

NATURAL HISTORY: Hairy Woodpeckers look so much like their cousin, the smaller Downy Woodpecker, that many of us find them a challenge to tell apart. The key is the beak: A Hairy Woodpecker's beak is almost as long as its head is wide. It uses this big chisel to pound on tree trunks and big limbs in search of insects, especially the larva of wood-boring beetles. This robin-sized woodpecker is found in forests with large trees, but will come to bird feeders for suet and peanuts. It moves up a tree trunk in a jerky motion, leaning back on its stiff tail feathers, then springing upward with both feet. – VC

Red-bellied Woodpecker

MALE

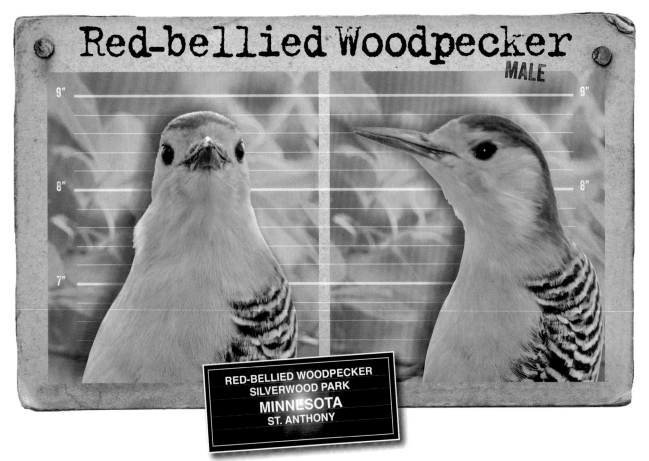

RED-BELLIED WOODPECKER
SILVERWOOD PARK
MINNESOTA
ST. ANTHONY

MUG SHOT: The Red-bellied Woodpecker has a long, sturdy and sharply pointed beak, useful for excavating a nest cavity in a tree. Its face is plain except for pink to orange feathers on the cheeks. The red feathers on the back of this bird's head go from the base of the neck to the beak, indicating it is a male. A female has red on the back of her neck and a small patch of red above the beak, but the top of her head is gray. –EO

NATURAL HISTORY: Put together a striking, zebra-striped back and a red head cowl and you have a Red-bellied Woodpecker. This bird's not-very-apt name comes from the seldom-seen red wash on its belly, a field mark that's rarely visible as it hitches up a tree trunk in search of insects and spiders. This woodpecker will eat just about anything it can find, including plant seeds, fruit and nuts. Look for red-bellieds in mature forests, and listen for its calling card, a rich *churr* sound. Once a bird of the southeastern United States, they've been steadily extending their range northward. –VC

Pileated Woodpecker

MALE

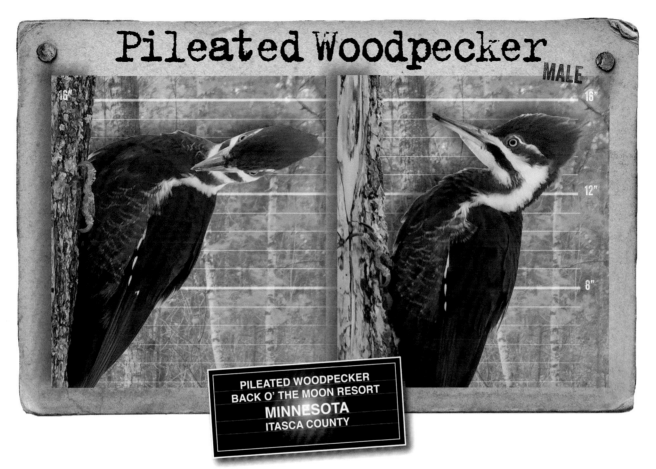

16"

16"
12"
8"

PILEATED WOODPECKER
BACK O' THE MOON RESORT
MINNESOTA
ITASCA COUNTY

MUG SHOT: In the top view of this Pileated Woodpecker, I'm struck by the wedge shape formed by the head and the beak, an efficiently shaped tool for chipping wood. No wonder it's able to create large nest cavities in huge trees. The red mustache, clearly visible in both views, tells me this is a male; a female's mustache is black. The brilliant red crest covers the entire top of the male's head. On a female, only the back half is red, the front part is speckled gray. –EO

NATURAL HISTORY: About the size of a crow, Pileated Woodpeckers are the largest woodpeckers in North America, known for their loud, resonant drumming on trees deep in the forest. Carpenter ants make up the majority of their diet, and they drill into dead trees or stumps in search of these insects. In fact, a walk through a forest may reveal a tree that looks bombed, with its bark lying in piles at the base, the work of a Pileated Woodpecker. They use their strong, chisel-like beak to excavate a nest hole, and these holes are used in later years by many wild animals, including owls, ducks, bats, flying squirrels and pine martens. –VC

Red-eyed Vireo

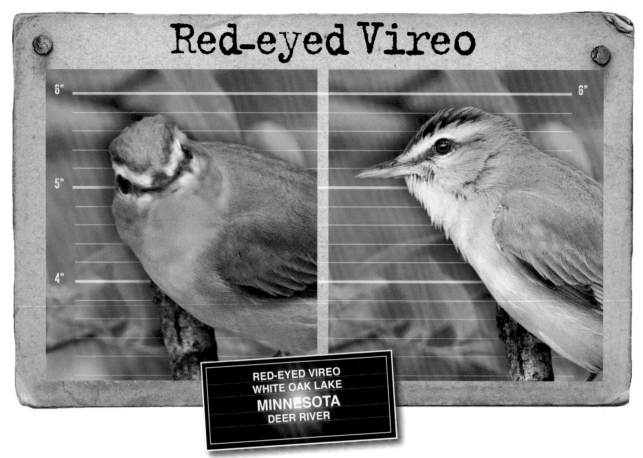

RED-EYED VIREO
WHITE OAK LAKE
MINNESOTA
DEER RIVER

MUG SHOT: Both the front view and side view confirm that a Red-eyed Vireo does indeed have a red eye. The side view also shows a thin black line starting behind the eye and extending forward all the way to the bird's beak. In the front view, those black lines from each eye converge at the beak, giving the impression of a great big grin across the bird's face. The front view makes it easy to see the vireo's gray cap bordered by a line of black feathers. –EO

NATURAL HISTORY: Tough to spot, this fairly drab bird spends its time high in the tree canopy, often hidden by leaves. The best way to identify this bird is by its song, a repetitive series of liquid notes, rising and falling as if the vireo was asking a question, then answering it *("Going up? Going down")*. They are known to sing throughout the day, even at mid-afternoon, when most other birds are silent. In fact, a researcher in 1952 counted how many times a single male Red-eyed Vireo sang its song in one day and recorded 22,000 of them. This bird's diet is almost entirely made up of insects. –VC

Blue-headed Vireo

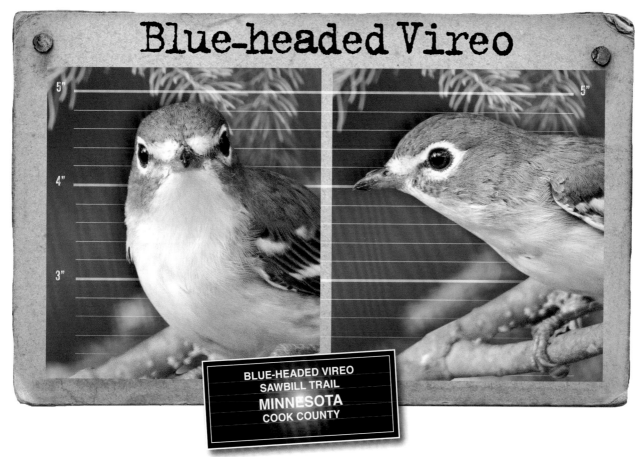

BLUE-HEADED VIREO
SAWBILL TRAIL
MINNESOTA
COOK COUNTY

MUG SHOT: The Blue-headed Vireo has prominent white eye rings that make its eyes appear even larger than they actually are. The front view confirms that the white continues across the face, leading people to say the bird has "spectacles." Both views verify this bird's name, "blue-headed." It has a short, stout beak, useful for plucking insects off leaves as it forages in the forest. Its white throat is not very noticeable in the side view but is easily seen in the front view. –EO

NATURAL HISTORY: The Blue-headed Vireo has several features that stand out from other vireos, including its handsome, dramatic plumage and habit of breeding in evergreen forests. During breeding season, this vireo is found in a broad swath across Canada's boreal forest, then spends its winters in the southeastern United States and as far south as the tropics. It forages methodically through tree limbs and leaves for insects, snatching everything from caterpillars to beetles to moths and ants, with spiders on the menu, as well. Males are unusual in helping to build the nest and incubating the eggs during nesting season. –VC

Yellow-throated Vireo

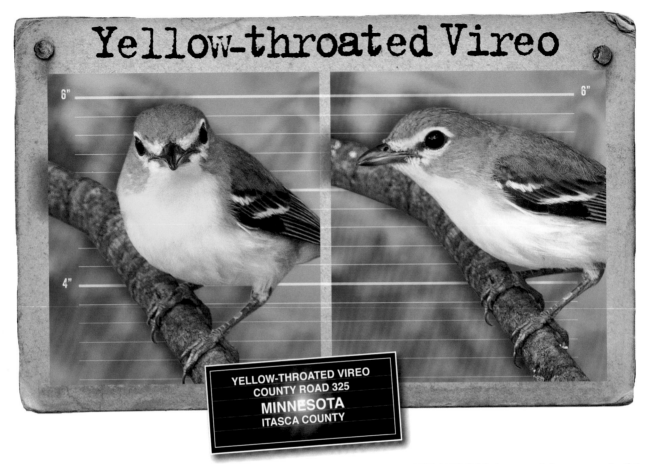

YELLOW-THROATED VIREO
COUNTY ROAD 325
MINNESOTA
ITASCA COUNTY

MUG SHOT: In many ways, the Yellow-throated Vireo looks like the Blue-headed Vireo. It also has "spectacles," but they are yellow instead of white. Note that the yellow around this bird's eyes do not make them "pop" as much as the white around the Blue-headed Vireo's eyes, even though both sets of "spectacles" are similar in size. This bird's namesake yellow throat is obvious in both photos. It also has a rather stout beak, useful for plucking insects from tree leaves and branches. –EO

NATURAL HISTORY: This is one of the most colorful members of the vireo family, but it's well camouflaged for its life in tall shade trees. Many birdwatchers learn to recognize its song, which sounds like "*three, eight*" repeated over and over, to locate the bird, most often in oaks or maples along a stream, lake or roadside. Foraging along twigs and amongst leaves, the Yellow-throated Vireo snaps up caterpillars, moths, butterflies, dragonflies, aphids, bugs and other insects, and adds berries to its diet in the fall. They're found widely in the eastern half of the United States during breeding season, and then head to the tropics for winter. –VC

Common Raven

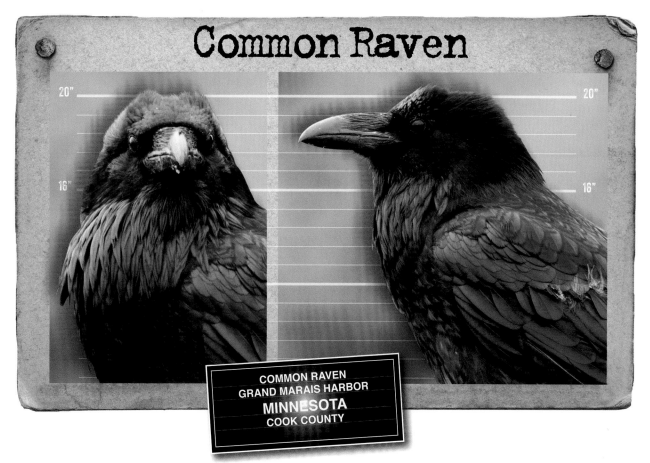

COMMON RAVEN
GRAND MARAIS HARBOR
MINNESOTA
COOK COUNTY

MUG SHOT: This raven's big honker of a beak looks a lot smaller in the front view. Also, looking at the side view, you could think the beak is fairly thin over its entire length, but the front view tells a different story. The light-colored section of the beak is the thin part but that is only about half the length. It's easy to see that the beak is quite broad at the base and tapers from there to the thinner part. Also note that feathers extend to cover more than half the beak. –EO

NATURAL HISTORY: Ravens are highly intelligent birds, among the smartest members of the avian family—some call them "flying monkeys" for their mental abilities. Their massive beaks scoop up everything from roadkill to insects, lizards to bird eggs and baby birds, even landfill leavings. Black from head to toe, ravens are impressive aerial acrobats, soaring, gliding and somersaulting through the air. A pair stays together all year (although not in flocks, like crows), and may remain mated for life. They're highly inquisitive and their unique croaking call clearly identifies a raven. –VC

Blue Jay

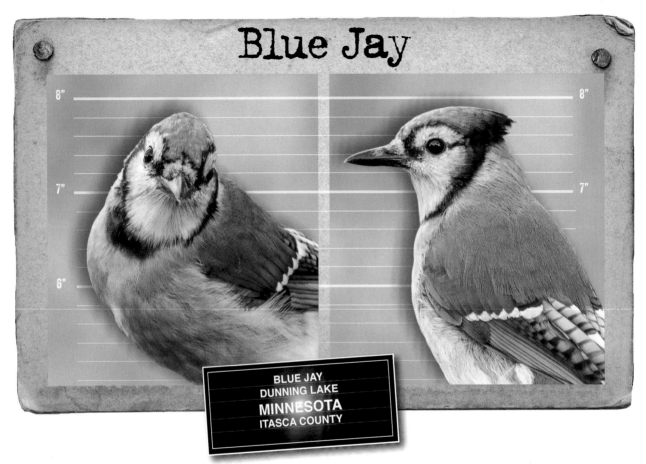

**BLUE JAY
DUNNING LAKE
MINNESOTA
ITASCA COUNTY**

MUG SHOT: The Blue Jay has a black collar circling its head. The side view shows blue and white head feathers neatly separated by black swirls and lines. The front view continues this pattern with black diagonal lines separating the blue feathers on top of the head from the white feathers near the beak. Its head feathers are long and can be raised when the bird is excited or agitated to form a tall crest on top of the head. –EO

NATURAL HISTORY: Known for their intelligence and strong family ties, Blue Jays are among the most colorful birds in the backyard. They're not a true blue, instead their color is caused by feather structures that scatter all but the blue in sunlight. Blue Jays make a range of raucous and sweet sounds and are excellent mimics, able to sound like various hawks. It's not known whether they do this to warn other jays of a hawk's presence, or to frighten other birds into scattering from feeders so they can feast alone. A favorite food is acorns, and Blue Jays plant many an oak in their food-hiding forays. –VC

Green Jay

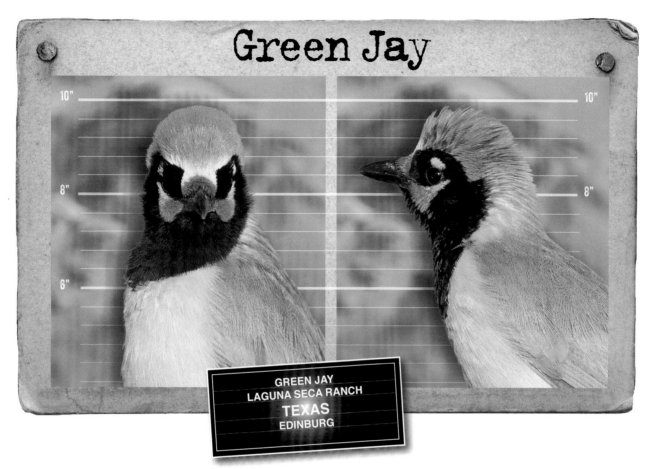

GREEN JAY
LAGUNA SECA RANCH
TEXAS
EDINBURG

MUG SHOT: Now here's a sinister looking character, at least from the front. The front view of this Green Jay makes it look like it's wearing a high-tech mask; you can hardly see its eyes. The side view shows us what's really happening. Connected to the black bib is a curved line of black feathers that completely encloses the eye. Features like that are called disruptive coloration; they help to break up the image of the bird so that it blends into its natural surroundings. —EO

NATURAL HISTORY: Most birdwatchers put this jay on their list of birds they'd most like to see, not surprising considering it's as colorful as a tropical parrot. And these are tropical birds, residing as far south as Honduras, barely making it into the United States, in southern Texas. This species is gregarious and noisy, but in its preferred habitat of open woodland and brushy thickets, its flashy plumage blends right into the dappled shade. They're omnivores, searching in trees and shrubs for seeds and fruit and a variety of insects and spiders, and then dropping to the ground to snatch centipedes, lizards and small rodents. —VC

Black-capped Chickadee

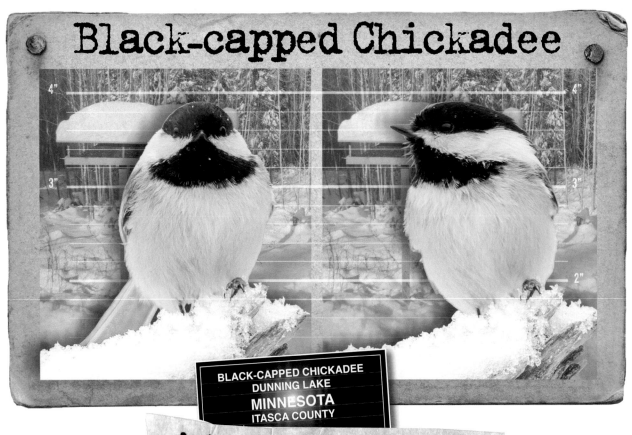

BLACK-CAPPED CHICKADEE
DUNNING LAKE
MINNESOTA
ITASCA COUNTY

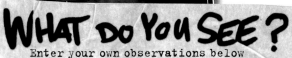

WHAT DO YOU SEE?
Enter your own observations below

Golden-crowned Kinglet

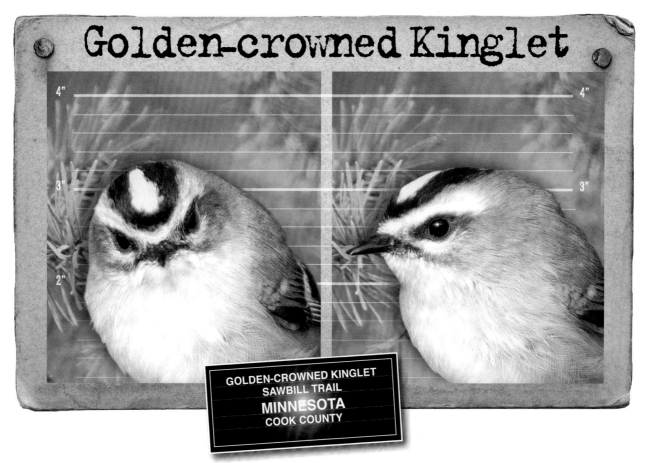

GOLDEN-CROWNED KINGLET
SAWBILL TRAIL
MINNESOTA
COOK COUNTY

MUG SHOT: The sight of a Golden-crowned Kinglet always brings a smile to my face because they are so darn cute! They are tiny and perky but hard to photograph because they're always on the move. The namesake golden head stripe is easily seen on both photos but the front view is best for seeing the black border surrounding it. The tiny, pointed beak does a disappearing act in the front view. The eye is surrounded by a patch of black feathers. –EO

NATURAL HISTORY: Golden-crowned Kinglets are tiny but hardy birds, able to survive winter nights as cold as 40 degrees below zero if they've consumed enough calories during daylight hours. Insects and their eggs make up most of this bird's diet, and they forage nonstop among branches and needles high in coniferous trees, making them a challenge to observe. A better bet is to listen for their high, tinkling song as they move rapidly through the forest. Up to 87 percent of them perish annually, but they compensate by raising two broods every year, with eight to 11 youngsters in each nest. –VC

American Robin

AMERICAN ROBIN
LONG LAKE REGIONAL PARK
MINNESOTA
NEW BRIGHTON

WHAT DO YOU SEE?

Enter your own observations below

Eastern Bluebird MALE

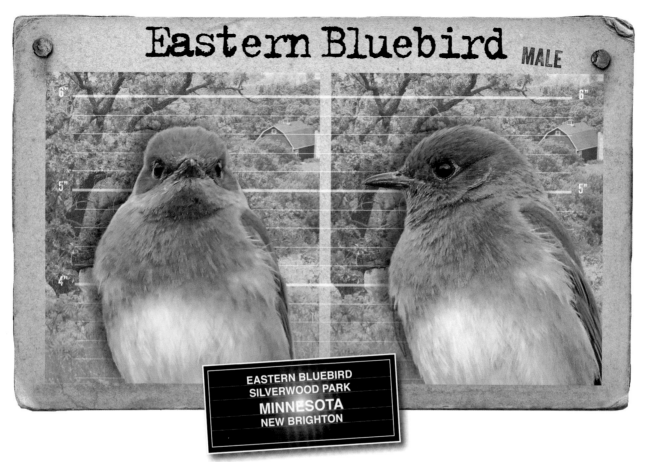

EASTERN BLUEBIRD
SILVERWOOD PARK
MINNESOTA
NEW BRIGHTON

MUG SHOT: The front view of this male Eastern Bluebird shows a very stern, almost angry, look on its face. Both views reveal a thin line of yellow at the base of the beak. A thin white eye ring is more noticeable in the side view. Brilliant blue feathers on the back and head and the rich orange breast indicate this is a male. A female has a similar color pattern but her colors are much more muted. –EO

NATURAL HISTORY: By the 1970s, many people under the age of 40 had never seen an Eastern Bluebird, their disappearance caused by competition from birds like the House Sparrow and loss of habitat. These cavity nesters needed holes in trees or fence posts in order to breed, and introduced species like sparrows and starlings were out-competing them for such sites. Concerted efforts by volunteers to construct nest boxes has led to a population rebound and now these gorgeous birds raise their young in meadows, golf courses, parks and even backyards. –VC

Northern Mockingbird

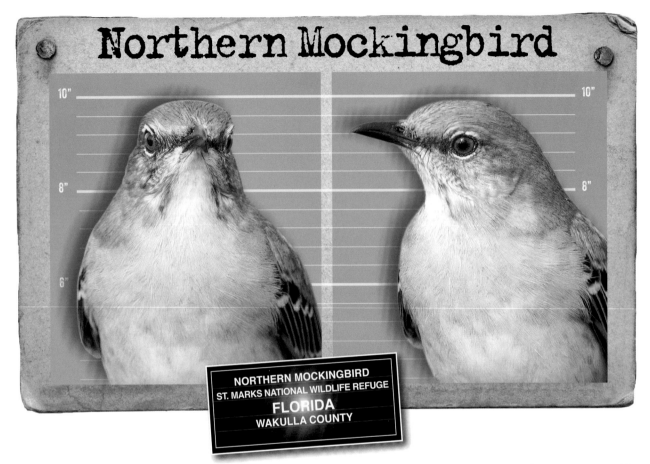

NORTHERN MOCKINGBIRD
ST. MARKS NATIONAL WILDLIFE REFUGE
FLORIDA
WAKULLA COUNTY

MUG SHOT: At first glance, this Northern Mockingbird seems to have a featureless face. However, a closer look at both views reveals a dark line between each eye and the beak. The white eye ring, broken at the front and back, is also visible in both views. The side view shows whiskers below the beak and an upper mandible that is slightly curved with a small hook at the end. Its golden eyes provide a little bit of color. –EO

NATURAL HISTORY: Many people are exasperated by Northern Mockingbirds for their seemingly endless singing and aggressive territorial behavior. But listen closely and you'll hear this accomplished mimic singing the songs of a variety of other birds, learning up to 200 bird songs in its lifetime. In fact, mockingbirds once were so valued for their singing that they were widely kept as cage birds. Both males and females can be belligerent, with females confronting other females and males battling other males and cats, dogs and even humans who approach too closely. They consume insects in spring and summer, berries and fruit the rest of the year. –VC

Cedar Waxwing

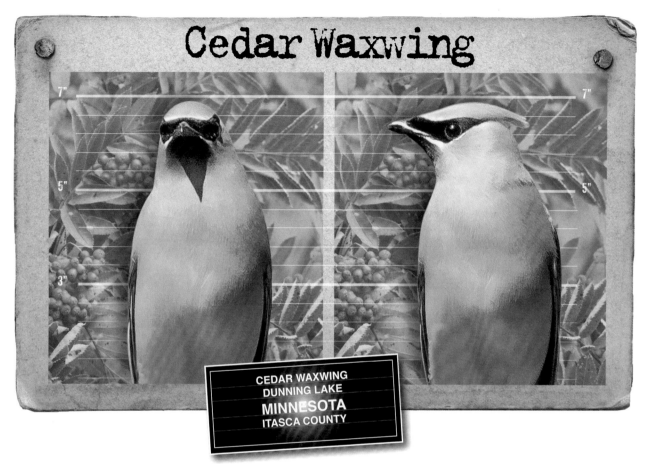

CEDAR WAXWING
DUNNING LAKE
MINNESOTA
ITASCA COUNTY

MUG SHOT: A "Lone Ranger mask" outlined in white encircles both eyes and wraps around the front of the face above the beak. Several bird species have their eyes surrounded by a patch of black feathers. Perhaps this is helpful in cutting down on bright sunlight, functioning like the black patches under the eyes of football or baseball players. Or it might hide their eyes to help them avoid being attacked by a predator. The side view shows this bird's flattened crest but the front view doesn't show it at all. –EO

NATURAL HISTORY: Cedar Waxwings have such sleek, silky plumage that their feathers look as if they were sprayed on. Much of their diet is made up of fruit, as they gorge on berries from mountain ash, crabapple, dogwood, wild cherry, juniper, mulberry, serviceberry, buckthorn and hawthorn. A gregarious species, they spend much of their lives in flocks, and a flock can strip all the berries from a shrub or small tree in a few hours. Look for them in winter in stands of cedar trees, wolfing down the berries, or listen for their high, lisping *tseet* call. They're aptly named for their red, waxy-looking wingtips, which may serve to help attract a mate. –VC

Chestnut-sided Warbler ^{MALE}

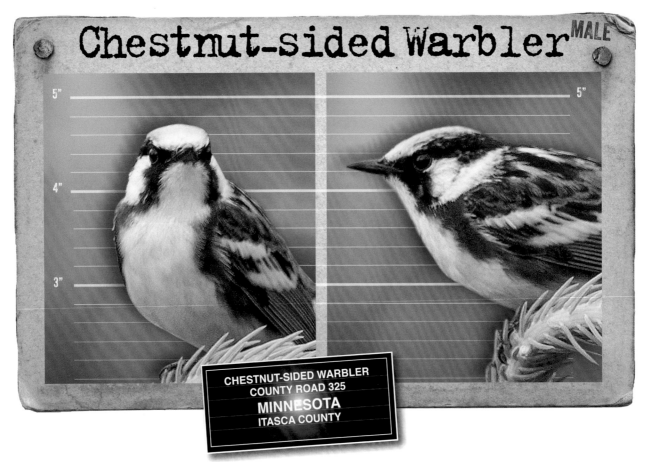

5"
4"
3"
5"

CHESTNUT-SIDED WARBLER
COUNTY ROAD 325
MINNESOTA
ITASCA COUNTY

MUG SHOT: This Chestnut-sided Warbler is shown in fresh breeding plumage. True to its name, there are rusty red feathers on its sides. The side view shows a sharply-pointed, thin black beak. The beak almost disappears in the front view. Its black eye is well hidden by two black stripes in the side view. In the front view, those black stripes on the head form an X. Other diagnostic field marks of this colorful warbler are a jaunty yellow cap and white and yellow wing bars. –EO

NATURAL HISTORY: This lively warbler searches for insects and other arthropods as it quickly hops from branch to branch with its tail cocked. It is generally found out at the tips of branches, foraging for its insect prey on the undersides of leaves. The male's rich, musical song sounds to many as if it's saying, "*please, please, pleased to MEET-ya*" as it seeks to attract a mate. It's apparently more numerous and more widely distributed than in the past: It prefers dense thickets and second-growth deciduous woods for nesting, and these habitats are on the increase after forests were cleared and pastures abandoned. –VC

Chestnut-sided Warbler

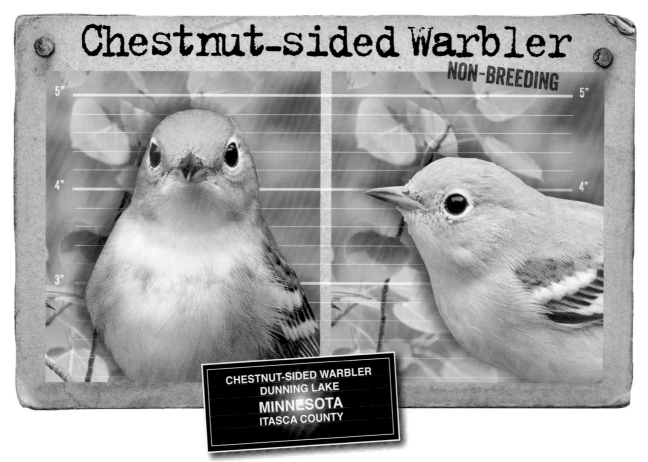

CHESTNUT-SIDED WARBLER
DUNNING LAKE
MINNESOTA
ITASCA COUNTY

MUG SHOT: This Chestnut-sided Warbler is in non-breeding plumage, dramatically different from the more colorful plumage it will acquire by next summer (see opposite page). The black beak has changed to a bi-color beak with a pink lower mandible but it still has a dark tip. In breeding plumage, the black eye was obscured by black stripes of feathers. Now, a prominent white eye ring makes the eye stand out. It still has a yellow cap but the yellow now extends all the way down the bird's back. Although the chestnut-colored feathers are not visible in the side view, the front view shows that some chestnut color remains under the wings. –EO

Northern Parula MALE

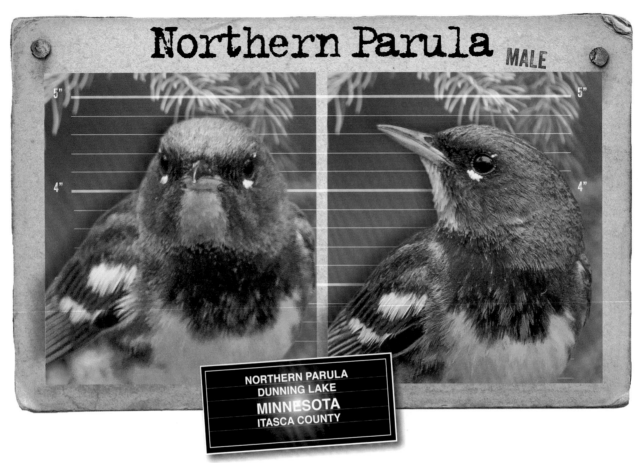

NORTHERN PARULA
DUNNING LAKE
MINNESOTA
ITASCA COUNTY

MUG SHOT: The Northern Parula is a warbler despite not having "warbler" in its name. In the front view, you can see that there is a very thin line of black feathers right below the beak that separates the beak from the yellow throat feathers. Without this black line, the lower mandible could easily be mistaken for part of the yellow throat. Black stripes connect the beak to the eyes and break up the white eye ring. The white spots under the eyes are prominent in both views. –EO

NATURAL HISTORY: Northern Parulas are one of the smaller members of the warbler family, and they spend most of their time foraging for insects on leaves and twigs high in the trees, making them tough to spot. But they have an easily recognizable song, not a warble but more like a rising buzzy trill (sounding to me a bit like a piece of the *William Tell* Overture). Males sing over and over as they move busily through the canopy in search of a meal. Birds in the South often build their nests in hanging Spanish moss, while northern birds use lacy tree lichen. –VC

Blackburnian Warbler

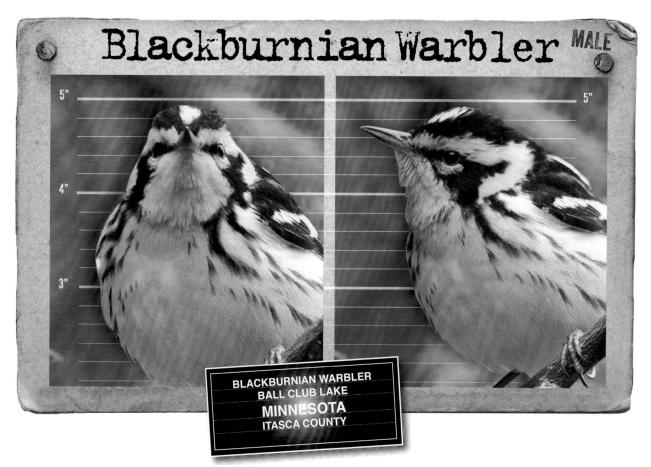

BLACKBURNIAN WARBLER
BALL CLUB LAKE
MINNESOTA
ITASCA COUNTY

MUG SHOT: The Blackburnian Warbler is often nick-named "fire throat" and these photos show why. You get the full effect of the stunningly bright orange throat in the front view. The side view shows an intricate facial pattern of yellow, black and orange feathers. Add to that the black and white patterns on the bird's back, wings and sides and you have one of our most colorful warblers. As is true of many songbirds, the front view makes it clear that the eyes and beak are in a straight line. –EO

NATURAL HISTORY: This is a "warbler neck" bird, the phrase that birdwatchers use to describe the strain that comes from bending one's neck back while trying to spot a bird foraging high in the canopy. The Blackburnian Warbler spends much of its time hopping from branch to branch in coniferous or mixed forests, using its tweezer-like beak to glean prey from leaves and branch tips. Like most warblers, its diet relies heavily on insects, such as caterpillars, beetles and mayflies. Blackburnian Warblers (named for an English naturalist) also pounce on spruce budworm caterpillars, and may help control local outbreaks of this harmful forest pest. –VC

American Redstart MALE

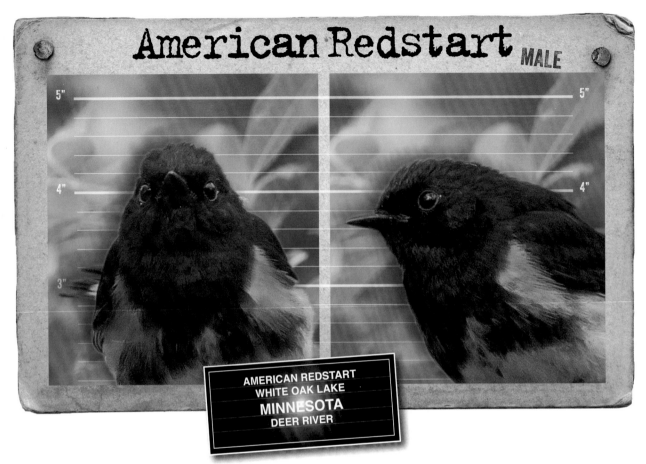

AMERICAN REDSTART
WHITE OAK LAKE
MINNESOTA
DEER RIVER

MUG SHOT: This male American Redstart, with his orange and black plumage, makes me think of Halloween. A female is gray where he is black, and would have yellow feathers where the male has orange feathers. Its black eyes disappear into the black feathers on its head, chest and back. In the side view, the beak looks thin and sharply pointed, but the front view reveals that it is triangular when viewed from below. –EO

NATURAL HISTORY: Many people say this handsome warbler looks like a tiny Baltimore Oriole, with its stunning orange and black plumage. The color on its wings and tail serve a purpose in helping redstarts as they hunt. A very active and acrobatic warbler, it hops from twig to twig, suddenly fanning its tail to startle insects into action, then the bird flies out and catches its prey on the wing. They seem to always be in motion, but their distinctive plumage and feeding style make them easy to spot. Look for redstarts low or at mid-level in deciduous forests near water. –VC

Black-and-white Warbler

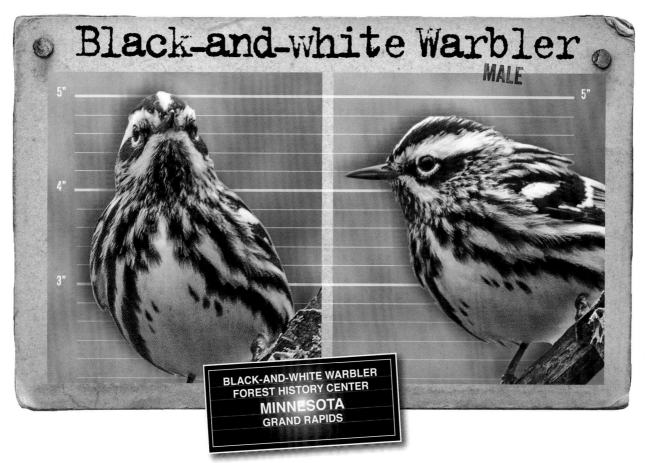

BLACK-AND-WHITE WARBLER
FOREST HISTORY CENTER
MINNESOTA
GRAND RAPIDS

MUG SHOT: The Black-and-white Warbler would look the same even if the photos in this book were not in color. I've always been impressed by how attractive it is even without bright colors. At first glance, the side view makes you think this bird has only half an eye ring, under the eye. A closer examination reveals small white feathers around the top of the eye, as well. They are hard to see because they blend in so well with the white stripe above the eye. –EO

NATURAL HISTORY: Some think of this as the "zebra warbler," with its distinctive black and white plumage. Its foraging style is distinctive, as well: Instead of hopping or flitting through the forest canopy, this warbler zigs and zags along tree trunks and branches, more like a nuthatch than a warbler, searching for insects and spiders hidden in the bark. During the breeding season, much of the Black-and-white Warbler's diet is composed of butterfly and moth caterpillars, augmented by ants, flies, beetles and spiders. This bird is a favorite of beginning warbler watchers, since it's easy to recognize and easy to see, as it forages busily. –VC

Cape May Warbler

MALE

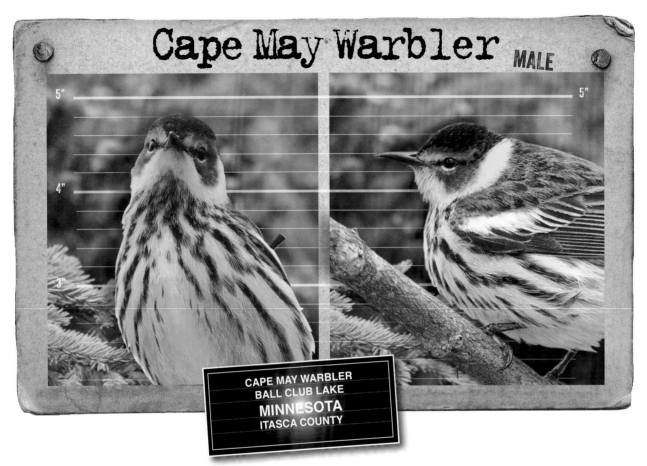

CAPE MAY WARBLER
BALL CLUB LAKE
MINNESOTA
ITASCA COUNTY

MUG SHOT: Here is a Cape May Warbler in breeding plumage. The black cap and chestnut-colored patch of feathers around the eye indicate this is a male. He has a typical warbler beak, thin and sharply pointed. The thick, white wing bar is clearly visible in the side view but not as noticeable in the front view. A collar of yellow feathers circles his head and the front view confirms that it goes all the way across his throat. In the side view, note the thin semi-circle of yellow feathers under his eye. –EO

NATURAL HISTORY: The Cape May differs from other warblers in several key ways: It feeds heavily on spruce budworm, a destructive forest pest, in years of heavy outbreaks. Its tongue is somewhat tubular, allowing it to feed on flower nectar and juice from fruit it pierces, and its plumage is almost a grab bag of markings, from its colorful cheeks to striped chest to white wing bars. This acrobatic warbler is a high-canopy bird, often found out at the ends of branches, head tipped down to snatch insects from the tips of needles. For a sweet treat, it will raid the sap-filled holes in tree bark drilled by Yellow-bellied Sapsuckers. –VC

Nashville Warbler

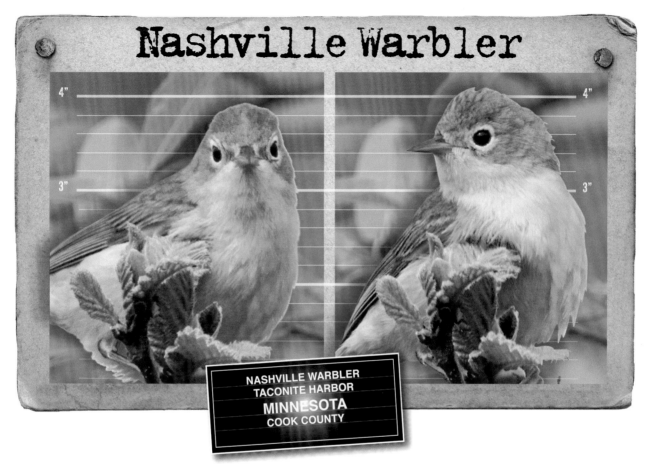

NASHVILLE WARBLER
TACONITE HARBOR
MINNESOTA
COOK COUNTY

MUG SHOT: The Nashville Warbler has bold white eye rings which make its black eyes stand out in both the front and side views. The eye rings completely encircle the eyes. Its typical, small warbler-type beak ends in a sharp point. Male and female Nashville Warblers look alike. They are distinguished from other plain-looking warblers by their gray heads and yellow throats. The front view shows a thin line of white feathers separating the gray of the head from the yellow of the throat. –EO

NATURAL HISTORY: This medium-sized warbler resembles several other warblers, with its yellow and olive feather coat, but once birdwatchers catch sight of that dramatic white eye ring, its identity is no longer in doubt. They're active birds, gleaning insects and their caterpillars from leaves in the lower levels of trees and from shrubbery. This warbler's name is a misnomer, since it breeds far north of Tennessee. An early naturalist collected a member of the species in Nashville on migration, and gave it the city's name. Look for this handsome bird in open woods, bogs and brushy pastures and listen for its loud, musical song. –VC

Magnolia Warbler FEMALE

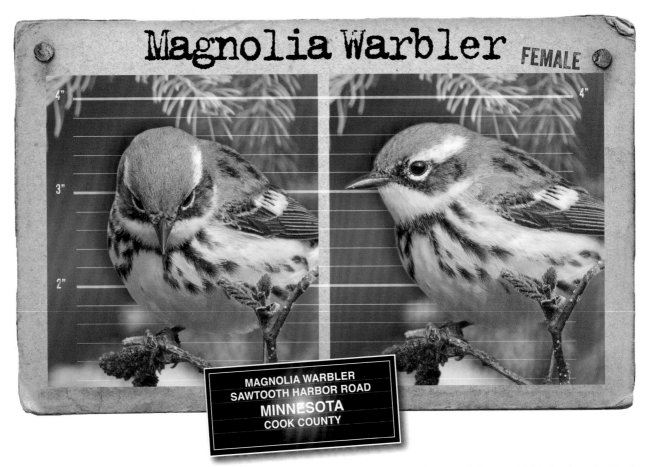

MAGNOLIA WARBLER
SAWTOOTH HARBOR ROAD
MINNESOTA
COOK COUNTY

MUG SHOT: Here is a modified mug shot, seen from the top instead of the front. It provides an interesting perspective on the bird's beak shape. It is broad at the base (near the head) and ends in a sharp point. The side view gives the impression that the beak is round and thin for its entire length. The Magnolia Warbler has almost complete white eye rings and a wide, white stripe extending back from each eye. The partial white wing bar and lack of black mask indicates this is a female. –EO

NATURAL HISTORY: This small bird takes the basic warbler color palette—yellow, black and white—and combines them to produce one of the most beautiful and striking birds in the family. A Magnolia Warbler is always a thrill to see and often is easy to observe, as it forages for insects close to the ground and out in the open. Its unlikely name was chosen by an early naturalist who observed one in a magnolia tree in the South during migration. Magnolia Warblers breed in the far north and northeast in evergreen forests, and glean their insect diet from spruce needles and deciduous leaves. –VC

Black-throated Green Warbler

FEMALE

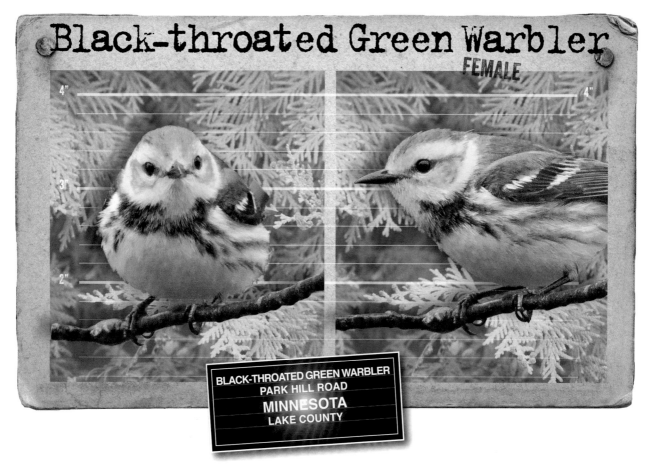

BLACK-THROATED GREEN WARBLER
PARK HILL ROAD
MINNESOTA
LAKE COUNTY

MUG SHOT: I know that Black-throated Green Warblers nest near our lake home in northern Minnesota because I hear their distinctive *zee-zee-zee-zoo-zee* call all summer. This is a female; the black on a male's throat would start right under the beak and extend much farther down the chest. The bright yellow face is overlaid with greenish streaks. In the front view, these streaks form a loop running from the beak, through the eyes and back to the beak. –EO

NATURAL HISTORY: For many birdwatchers, spring is not complete without some sightings of this stunning and easily recognizable warbler, with its black throat, bright yellow face and greenish back. Its distinctive song is another clue to this warbler's identity, a series of high-pitched *zoos* and *zees*, a familiar sound of the northeastern forest in springtime. This active bird may sing its song hundreds of times an hour to attract a mate or define a territory. Many of us spot Black-throated Green Warblers as they make their annual migratory trip between the tropics and the areas where they breed. –VC

Golden-winged Warbler

MALE

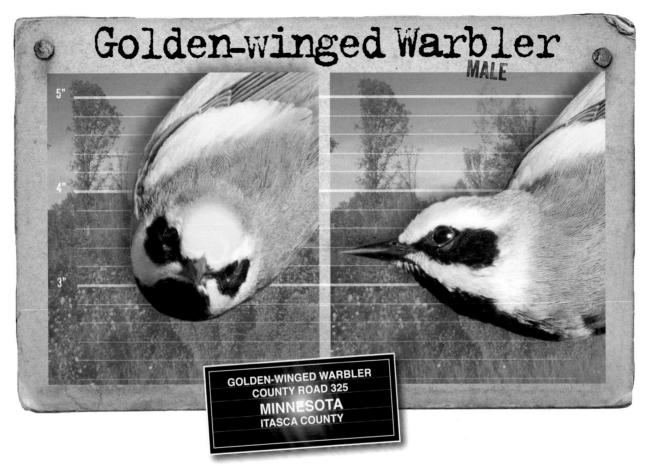

GOLDEN-WINGED WARBLER
COUNTY ROAD 325
MINNESOTA
ITASCA COUNTY

MUG SHOT: Both views of this Golden-winged Warbler show the large patch of yellow wing feathers that give the bird its name. The front view provides an especially good look at the black eye patches, yellow cap and black throat. The front view makes the bird look like it's wearing a pair of black sunglasses. The black throat and eye patches indicate this is a male; those features would be gray on a female. The short, thin beak is typical of the warbler family. –EO

NATURAL HISTORY: The uncommon Golden-winged Warbler has suffered a severe decline in its population over the past 50 years, one of the steepest drops among songbirds. A major factor is its requirement for two separate habitats in breeding season—young trees for nesting and mature forest edges for foraging later in the season. Another reason for the decline is this warbler's interbreeding with its cousin, the Blue-winged Warbler, creating distinctive hybrids. Many conservation organizations have joined together with the goal of boosting the warbler's population by 50 percent over the next 50 years. –VC

Canada Warbler
MALE

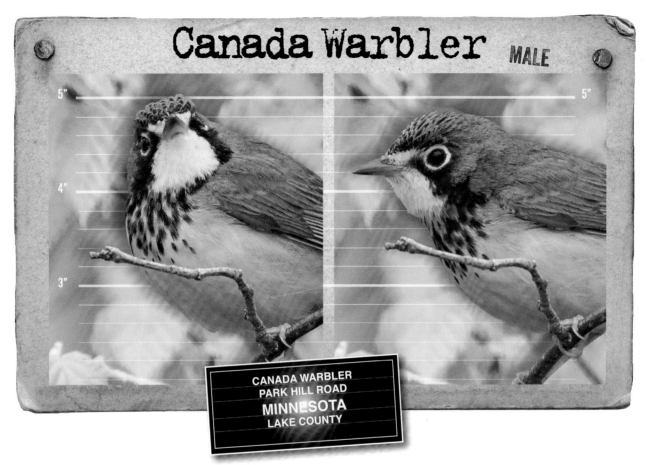

CANADA WARBLER
PARK HILL ROAD
MINNESOTA
LAKE COUNTY

MUG SHOT: The Canada Warbler in my photo has unusual eye rings; the top half of each one is yellow and the bottom half is white. These prominent eye rings give the bird a wide-eyed look. Black streaks on the otherwise plain yellow chest are often referred to as a "necklace." Notice the black tip on the pink beak. This close-up look at the bird's forehead shows that it is covered with tiny black feathers with gray edges. In the front view, they almost look like scales. –EO

NATURAL HISTORY: This warbler is a long-distance migrant, heading out of and back to northern South America in the spring and fall. Its journey is so long that it's one of the last warblers to arrive in spring and among the first to leave in autumn. They're active foragers for insects, hopping through dense cover, flushing their prey and then catching it on the wing. They engage in this feeding style so often that they formerly were known as the Canadian Flycatching Warbler. Look for this handsome bird foraging in dense woodlands and brush, often in the undergrowth and low branches. –VC

Yellow-rumped Warbler

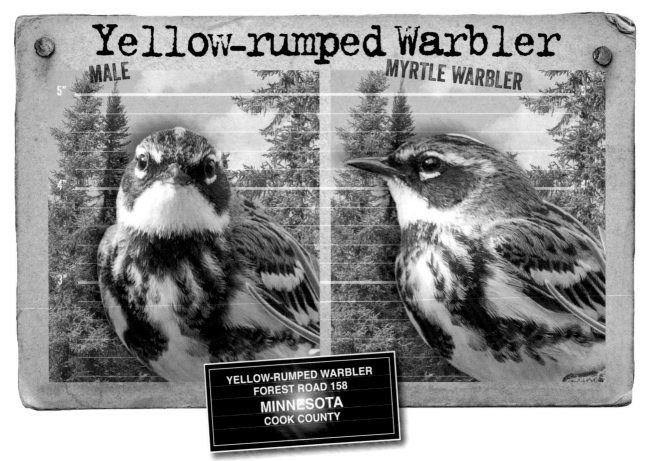

MALE

MYRTLE WARBLER

5"

5"

4"

3"

YELLOW-RUMPED WARBLER
FOREST ROAD 158
MINNESOTA
COOK COUNTY

MUG SHOT: One of two distinct subspecies of the Yellow-rumped Warbler, this one is often referred to by its former name, Myrtle Warbler. In 1973, scientists found that this bird and the Audubon's Warbler were so closely related that the two were considered the same species. In the front view, the dark patches around its eyes look like a mask. Both views show white crescents above and below the eyes. The pure white throat is one feature that distinguishes the Myrtle from the Audubon's subspecies. –EO

Audubon's breeding

Myrtle breeding

NATURAL HISTORY: Common and widespread, this warbler is found across the continent's northern and eastern zones. Myrtle Warblers change dramatically from season to season, exchanging their drab, mostly taupe winter plumage for striking black, gray, white and yellow breeding season feathers. In all seasons, however, this warbler lives up to its species' name, showing a distinctive yellow rump patch. Its ability to digest bay berries and wax myrtle berries (hence its name) allows it to winter farther north than most other warbler species. One of its many foraging styles is to dart out after insects, as flycatchers do. –VC

Yellow-rumped Warbler

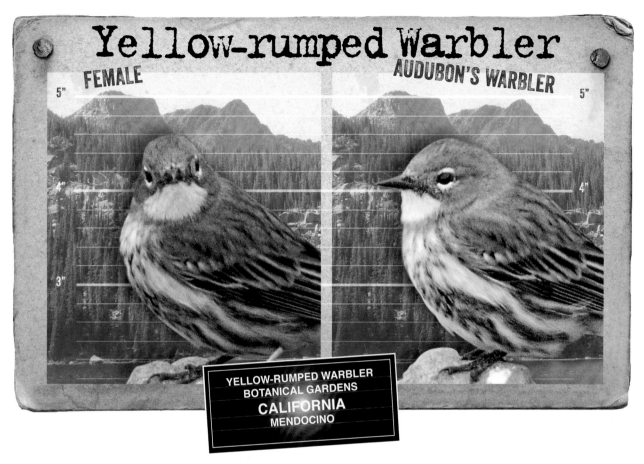

FEMALE

AUDUBON'S WARBLER

5"

5"

4"

4"

3"

YELLOW-RUMPED WARBLER
BOTANICAL GARDENS
CALIFORNIA
MENDOCINO

MUG SHOT: This is the Audubon's subspecies of the Yellow-rumped Warbler. Scientists are reconsidering the 1973 decision to combine these two subspecies and by the time you read this book, they might be separated again. That decision will be made based on DNA differences. Audubon's has a yellow throat and Myrtle has a white throat. Both have white crescents above and below the eyes but the Audubon's lacks the black mask of the Myrtle. Both have yellow on their sides. –EO

Audubon's breeding

Myrtle breeding

NATURAL HISTORY: An insect-eater in warm seasons, the Audubon's Warbler switches to fruit in winter, including the berries of juniper, poison oak and dogwood and grapes. They also eat wild seeds and may come to bird feeders for sunflower seeds, raisins and suet. Their different songs, as well as their plumage differences, help distinguish between the two subspecies. Unlike many warbler species, this one can be conspicuous as it perches on outer limbs, often in evergreen forests. Like nearly all warblers, they forage in trees for insects, but also pluck them from the water's surface and pick them out of spider webs. –VC

Common Yellowthroat

MALE

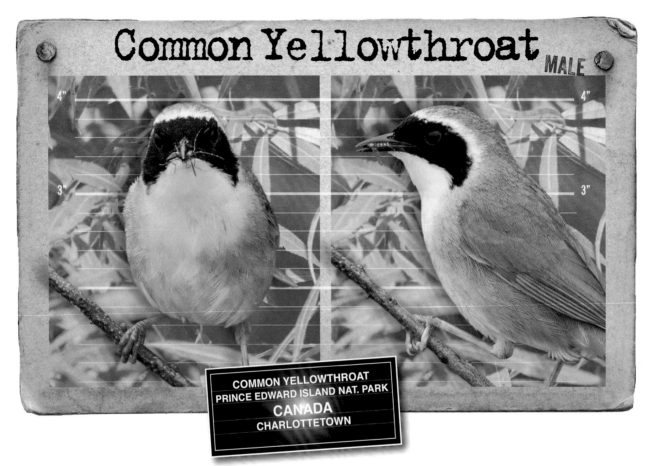

COMMON YELLOWTHROAT
PRINCE EDWARD ISLAND NAT. PARK
CANADA
CHARLOTTETOWN

MUG SHOT: In the front view of this Common Yellowthroat, the black mask and gray hood remind me of a motorcycle helmet. That black mask tells us this is a male. The female's face is olive gray without a black mask. As their name implies, both male and female have a yellow throat. Both views show a thin line of light-colored feathers across the top of the black mask. This bird used its thin, sharp beak to capture a small insect. –EO

NATURAL HISTORY: Many people call this small warbler the "witchety bird," for its distinctive sounding *witchety-witchety-witch* song, one of the easiest to learn in the bird world. These are active warblers, usually allowing only a quick look as they pop up to sing from a tall reed, then resume skulking among the vegetation in marsh and wetland habitats. They're the only warbler that nests in open marshes, a clue for locating them as they hunt for moths, aphids, small caterpillars, mayflies and other insects. Common Yellowthroats are one of the most numerous of warblers and are less shy than many others in their family. –VC

Yellow Warbler

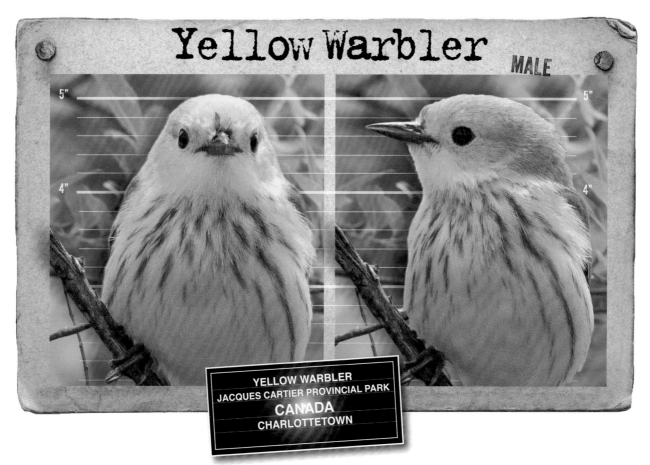

YELLOW WARBLER
JACQUES CARTIER PROVINCIAL PARK
CANADA
CHARLOTTETOWN

MUG SHOT: The Yellow Warbler is a bright but relatively unmarked member of the warbler family. It lacks fancy facial patterns. The only decorative feature of its plumage is thin reddish stripes on its chest. These stripes indicate this bird is a male. A female would have a less boldly marked breast. Unlike many warblers, the Yellow Warbler's face lacks markings such as a dark mask over the eyes or eye rings. Note the small, sharp beak, typical of warblers. –EO

NATURAL HISTORY: This is one of the easiest warblers to spot, a brilliant yellow bird that spends much of its time at eye-level in low shrubs and trees. It prefers moist habitats that produce a wide variety of insects. Look for Yellow Warblers hopping from branch to branch in streamside willows and at woodland edges, using their sharp beaks to pluck insects from twigs and leaves. They consume caterpillars, mayflies, moths, beetles and damselflies, even mosquitoes. This is one of the most commonly heard warblers, singing its rapid, distinctive song over and over, sounding as if it's saying, "*Sweet, sweet, sweet, I'm so sweet.*" –VC

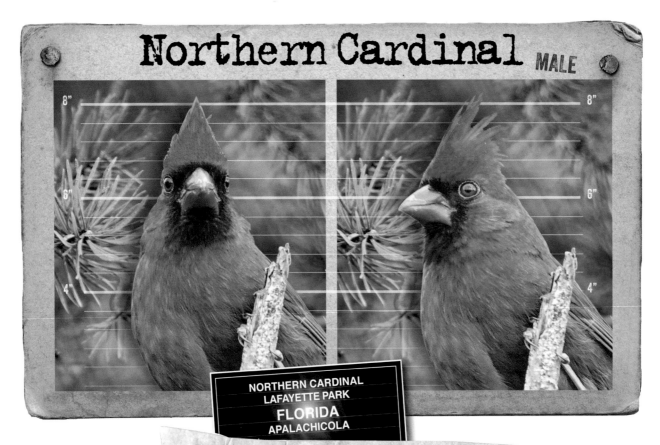

NORTHERN CARDINAL
LAFAYETTE PARK
FLORIDA
APALACHICOLA

WHAT DO YOU SEE?

Enter your own observations below

Painted Bunting

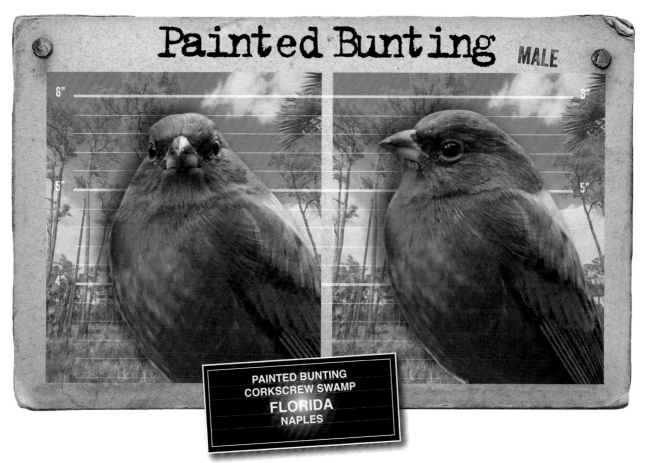

PAINTED BUNTING
CORKSCREW SWAMP
FLORIDA
NAPLES

MUG SHOT: Many people consider the male Painted Bunting our most colorful songbird and these photos, showing his red, blue, green and yellow feathers, confirm that. His blue feathers form almost a complete hood, broken only by the red feathers on his throat. Thin, red eye rings make his eyes stand out from the blue head feathers. The beak is thick and sturdy but ends in a very sharp point. The front view shows the base of the lower mandible as rectangular. –EO

NATURAL HISTORY: A vibrant feather coat is no guarantee of visibility, and Painted Buntings can be especially tough to spot as they skulk through low, dense vegetation. Listen for this species' flutey song, typical of the finch family. Thick beaks crack open a variety of grass and weed seeds for this ground forager, although its diet is primarily made up of insects during breeding season. Not just pretty birds, males are very aggressive about holding their territories and may harm each other as they fight. Once kept as cage birds in this country, they still are trapped and caged in Mexico and the Caribbean islands. –VC

87

Olive Sparrow

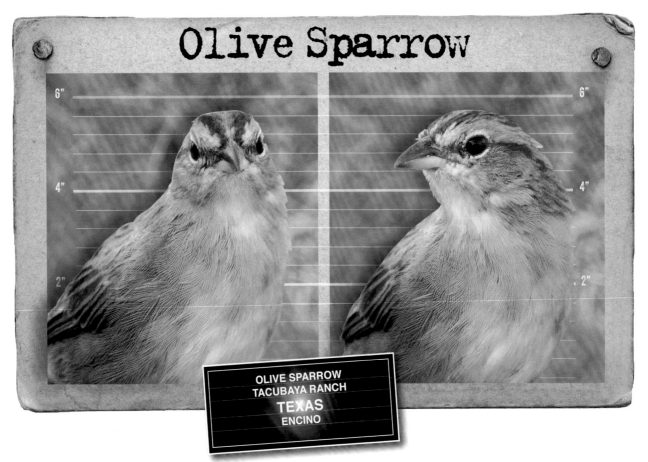

OLIVE SPARROW
TACUBAYA RANCH
TEXAS
ENCINO

MUG SHOT: Here is a sparrow with a bi-colored beak. The lower mandible of the Olive Sparrow also has a dark tip. Here's something to ponder: It's known that dark tips on feathers make them stronger, so might a dark beak tip make a beak stronger? I couldn't find any research answering this question. A white eye ring is visible in the side view but it has small breaks at the front and back of the eye. The front view shows a brown stripe on either side of a gray stripe on top of the head. –EO

NATURAL HISTORY: This medium-sized sparrow is mainly a Mexican species but can also be found as far north as southern Texas, where it's a common bird in the right habitat. This sparrow skulks among woodland undergrowth, as well as tangled shrubs and thorny bushes, and nests in short shrubs or cactus. The Olive Sparrow's song, made up of a series of accelerating chip notes, catches the ear and may be the only distinctive thing about this plain bird. In fact, the Olive Sparrow is said to be easy to hear but difficult to see, as it scratches its feet in leaf litter in its search for seeds and insects. –VC

American Tree Sparrow

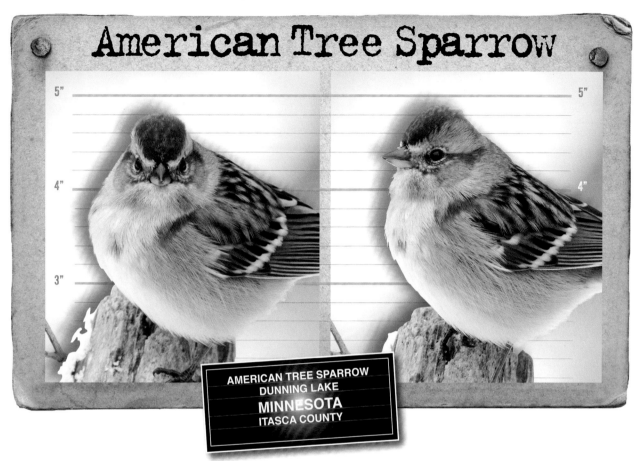

AMERICAN TREE SPARROW
DUNNING LAKE
MINNESOTA
ITASCA COUNTY

MUG SHOT: The prominent rusty cap of the American Tree Sparrow stands out in the front view. From the side view, the bi-colored beak is obvious. The upper mandible is black and because the lower yellow mandible is wider at the base, the front view looks like the bird is eating a kernel of corn. The front view shows that the bird's white throat is bordered on top by a thin line of brown feathers. Also note the brown streak behind the eye and the dark spot on the bird's chest. –EO

NATURAL HISTORY: Watch for this handsome red-headed sparrow in rural areas in winter, when small flocks feed on weed seeds on the side of the road, swirling up as each vehicle passes. They're plump sparrows with small, conical beaks and a distinctive "tie tack," a dark spot on the center of the plain chest. American Tree Sparrows are misnamed, since these medium-sized sparrows spend most of their time on the ground, even nesting on the ground on the Arctic tundra. They're very hardy, and may continue to forage even during a blizzard. A flock coming in to feed announces its presence with sweet, high-pitched twitters. –VC

Fox Sparrow

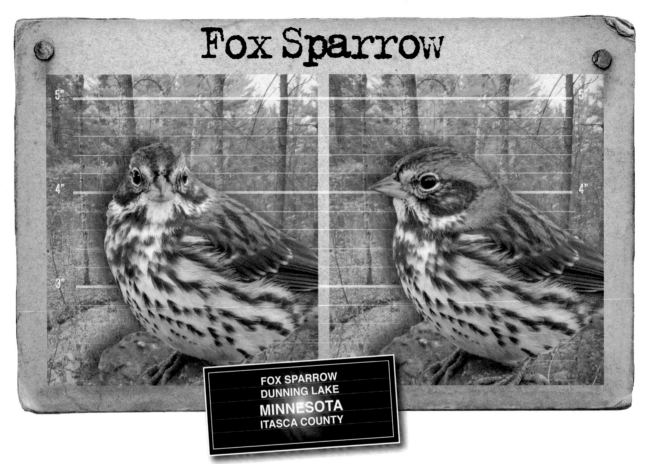

FOX SPARROW
DUNNING LAKE
MINNESOTA
ITASCA COUNTY

MUG SHOT: The Fox Sparrow has a bi-colored beak, and the front view shows that the lower mandible is all yellow, but has a dark tip. Also note that the upper mandible has a small yellow area on each side of the dark center. These photos show a thin, white ring around each eye but the side view reveals small breaks in the ring at the front and back of the eye. The gray feathers on the head and neck are best seen in the side view. But, the two brown stripes on the head are more visible in the front view. –EO

NATURAL HISTORY: The large, stocky Fox Sparrow is named for plumage that resembles the color of a Red Fox. They're fascinating birds to watch as they forage on the ground, scratching in leaf litter or on bare earth with a characteristic hop-skip movement. They grab litter (or mulch) in their toes and kick it backwards to expose seeds and insects. Fox Sparrows are fairly shy and spend most of their time in dense thickets or under trees at the forest's edge. This sparrow has a pretty song made up of whistles and trills, and was valued as a cage bird two centuries ago. Several distinctive populations may one day be separate species. –VC

Clay-colored Sparrow

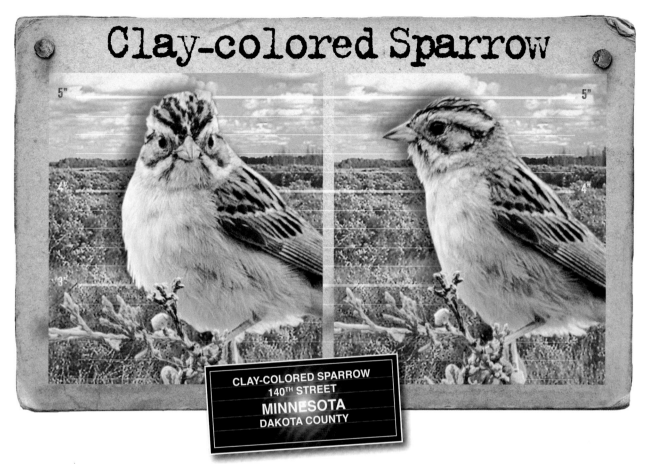

CLAY-COLORED SPARROW
140TH STREET
MINNESOTA
DAKOTA COUNTY

MUG SHOT: The beak of the Clay-colored Sparrow is pink but it has a dark tip. The front view reveals an interesting pattern on top of the head, with several dark brown and light brown stripes on both sides of a central white stripe. The complete pattern of stripes is not obvious in the side view. The side view shows several dark lines with white areas on the side of the head. In the front view, two thin, brown stripes start at the beak and extend down toward the chest. –EO

NATURAL HISTORY: Few of us notice this small, inconspicuous sparrow as it summers on the northern prairie, singing from shrubby perches but spending much of its time hidden from view on the ground. The Clay-colored Sparrow's dry, raspy song is often overlooked, as well, since it sounds like an insect buzzing. That small beak is perfectly suited to a diet of weed and grass seeds, plant buds and small insects like caterpillars, grasshoppers and ants, as well as spiders. After the breeding season, Clay-colored Sparrows forage in mixed sparrow flocks. These are busy little birds, often bustling from branch to branch and bush to bush. –VC

Black-throated Sparrow

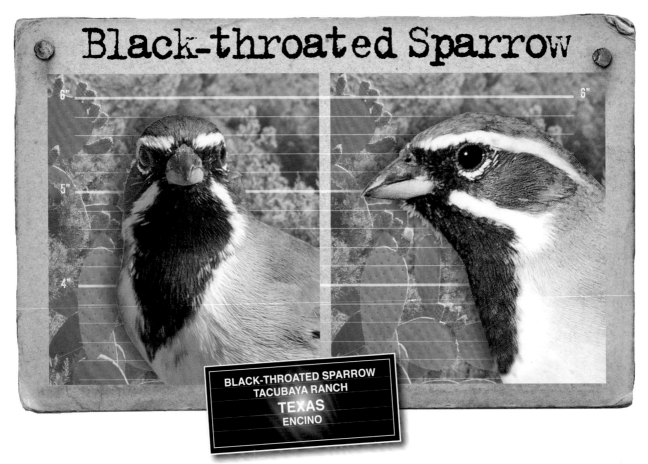

BLACK-THROATED SPARROW
TACUBAYA RANCH
TEXAS
ENCINO

MUG SHOT: Both photos show this Black-throated Sparrow to be appropriately named. In the side view, notice this is yet another sparrow with a bi-colored beak. The gray lower mandible has a dark tip. Instead of a complete eye ring, there is just a thin border of white feathers along the lower edge of the eye. In the side view, there are prominent white stripes both above and below the eye. In the front view, these thick, white stripes form an **X** across the face. –EO

NATURAL HISTORY: This medium-sized sparrow lives in the Southwest's open desert country, often on arid hillsides and in scrub habitat. They're seedeaters year round, adding insects to their diet during breeding season, hopping and sometimes running on the ground in search of food. Black-throated Sparrows are among the most common desert birds, and their dramatic markings make them stand out as they mingle in mixed flocks of birds foraging together in winter. In the generally treeless landscapes they inhabit, females build their nests in cactus or in desert shrubs. This bird's song is a series of metallic notes and trills. –VC

Bachman's Sparrow

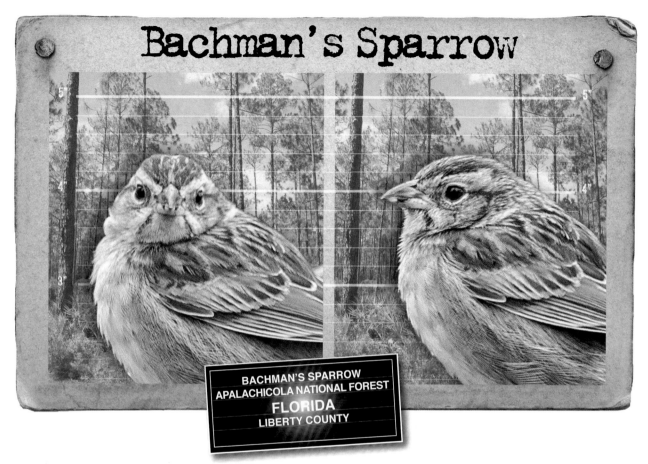

BACHMAN'S SPARROW
APALACHICOLA NATIONAL FOREST
FLORIDA
LIBERTY COUNTY

MUG SHOT: The front view shows thin, light streaks through its rusty cap. The bi-colored beak has an upper mandible that is mostly dark and a pink lower mandible with a dark tip. The sparrow in these photos has a black spot in the middle of the lower mandible but such a black spot is not found on most Bachman's Sparrows. Notice the thin, brown streaks behind the eyes and the dark streaks extending down from the beak. Both of these field marks are also seen on the Clay-colored Sparrow. –EO

NATURAL HISTORY: This large (as sparrows go) reddish sparrow lives in the southeastern United States in pine or oak woods with plenty of open grassy areas. As its preferred woody habitat disappears, it is forced into marginal areas such as utility rights-of-way and clear cuts. This uncommon and elusive sparrow has been described as extremely secretive and is often overlooked. Its lovely song stands out in the sparrow world, a clear whistle followed by a series of trills. Like many sparrows, the Bachman's Sparrow forages for seeds and insects, spending so much time on the ground, walking, running and hopping, that it almost seems reluctant to fly. –VC

White-crowned Sparrow

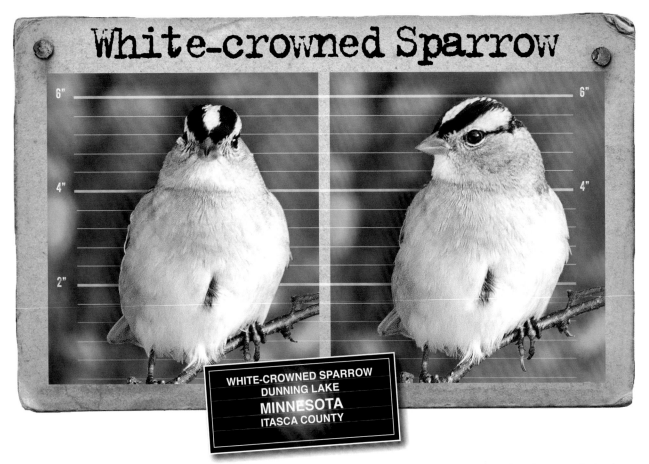

WHITE-CROWNED SPARROW
DUNNING LAKE
MINNESOTA
ITASCA COUNTY

MUG SHOT: The bird's name comes from the white stripe on top of its head, easily seen in both photos. The front view confirms that the thick, black stripes on the head come together at the beak. The dark tip on the end of its beak is most obvious in the front view. The side view shows a much thinner dark line from the eye to the back of the head. White-crowned Sparrows have an unmarked throat, chest and belly so the dark spot on this bird's belly is not typical. –EO

NATURAL HISTORY: This handsome, fairly large sparrow is a familiar and welcome sight over much of the United States in winter, found in all but the northern tier of states. Like most sparrows, they feed on weed seeds and insects, using a hop-skip technique, hopping backwards on the ground to sweep away ground litter, then skipping forward to pounce on the seeds or insect prey this action turns up. Look for them along roadsides, in brush or under feeders. Scientists are fascinated by the way this sparrow's song varies by location: Unlike many songbirds, they learn their species' song from birds in the "neighborhood," instead of from their fathers. –VC

White-throated Sparrow

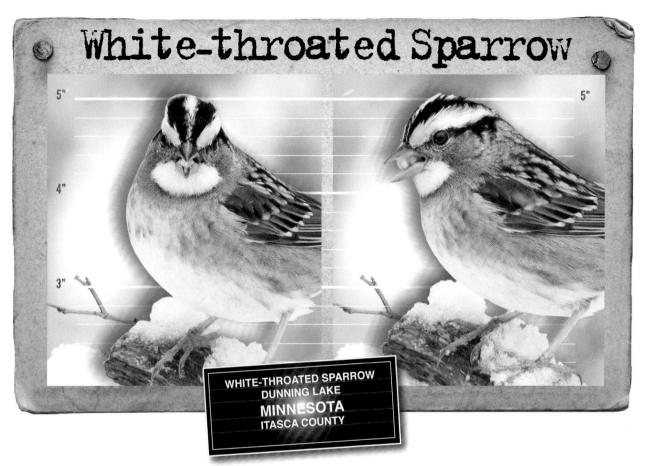

WHITE-THROATED SPARROW
DUNNING LAKE
MINNESOTA
ITASCA COUNTY

MUG SHOT: Some bird names don't seem to fit the bird but these photos confirm that White-throated Sparrow is the perfect name for this species. The distinctive yellow patch between the beak and the eyes stands out in both the front and side views. This area is called the "lores." This bird was migrating north to its breeding grounds in mid-April when northern Minnesota was still thawing out from winter. Its fresh breeding plumage makes this an especially beautiful bird. –EO

NATURAL HISTORY: This plump sparrow has one of the most arresting songs in the sparrow family, singing a series of sweet, wavering whistles that sound to many like "*Oh, sweet Canada, Canada, Canada,*" a most welcome sound of spring and summer. Look for this sparrow on the ground as it hops and scrapes to uncover seeds and insects, sometimes so vigorously that leaf litter is tossed far and wide. Not all White-throated Sparrows show the bright white head stripes and chin patch—many have duller, tan markings. Some people mistakenly assume that the tan birds are females. Oddly, a bird with bright white stripes almost always mates with a tan version. –VC

Red-winged Blackbird 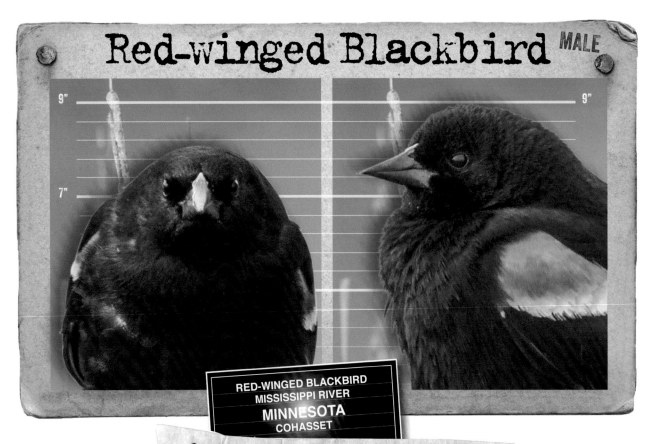MALE

9"

7"

9"

RED-WINGED BLACKBIRD
MISSISSIPPI RIVER
MINNESOTA
COHASSET

WHAT DO YOU SEE?
Enter your own observations below

Yellow-headed Blackbird

MALE

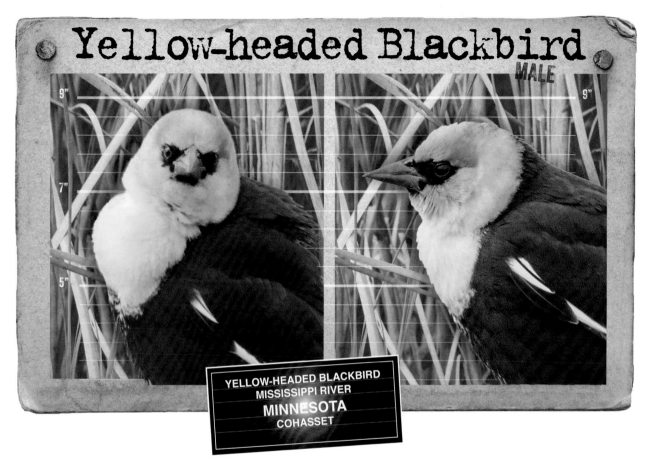

9"

7"

5"

9"

YELLOW-HEADED BLACKBIRD
MISSISSIPPI RIVER
MINNESOTA
COHASSET

MUG SHOT: This male Yellow-headed Blackbird is well named, with his bright yellow head and chest. The rest of his body is black except for the white patches on his wings. A female Yellow-headed Blackbird looks very different, mostly brown with a dull yellow chest and only small patches of yellow on her head. The side view shows a sharply pointed beak, typical of members of the blackbird family. Both views show the small mask of black feathers that surrounds the eyes and beak. –EO

NATURAL HISTORY: Looking as if it fell head first into a can of yellow paint, this striking blackbird nests along with others of its kind in marshes. A male will attract a harem of up to eight females to breed in his territory. Its harsh song, called by some the worst-sounding song of any bird in North America, calls to mind a rusty gate being opened. Yellow-headed Blackbirds consume insects during summer, and then switch to a seed diet for the rest of the year. They forage on the ground, often in rolling flocks, with the birds in back flying to the front to feed. –VC

Bobolink

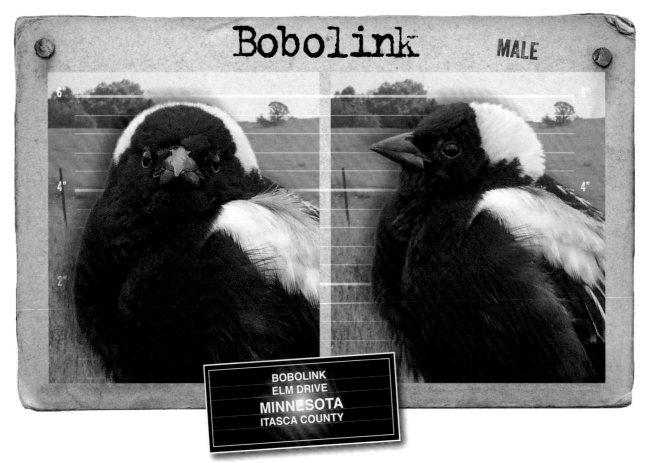

BOBOLINK
ELM DRIVE
MINNESOTA
ITASCA COUNTY

MUG SHOT: The yellow and black head feathers of this male Bobolink form a starkly contrasting pattern. In the front view, the yellow feathers look like a tight-fitting cap and the side view reinforces that idea. White feathers on his back and wings complete the breeding plumage of this mostly black bird. The pattern of light on top and dark underneath is unique among North American songbirds. His non-breeding plumage is totally different, brown and streaky like a sparrow. –EO

NATURAL HISTORY: The Bobolink's unusual markings cause some to say it looks like a bird wearing a tuxedo backwards. It's named for the sound of the tinkley, burbling song it sends over hay fields and meadows in spring and early summer. Watch for males fluttering in an unusual helicopter-like flight over open fields. A member of the blackbird family, it has one of the longest migrations among songbirds, traveling more than 12,000 miles each year to and from South America. Its population is in severe decline, due to rapidly disappearing grasslands in its summer range, and use of pesticides on both its winter and summer grounds. –VC

Boat-tailed Grackle MALE

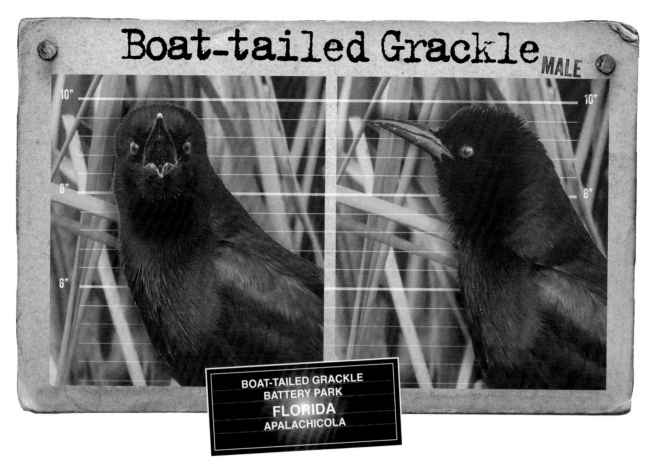

BOAT-TAILED GRACKLE
BATTERY PARK
FLORIDA
APALACHICOLA

MUG SHOT: The front view of this male Boat-tailed Grackle gives an interesting look at the shape of his beak. The groove in his lower mandible lets the upper mandible fit snugly into the lower. Another interesting feature is the placement of his eyes. The front view shows them to be more oriented toward the front than the sides. Because he is not a prey species, he doesn't need to be as worried about danger from behind. (See the Spruce Grouse for eyes pointed to the sides.) –EO

NATURAL HISTORY: These large, conspicuous black-birds with their extremely long tails strut along beaches on the Gulf and Atlantic coasts (and interior Florida) in their search for food. Those big beaks are capable of pulling open tightly closed mussel shells, and they search along the shore and in the water for shrimp, tadpoles, frogs, small fish and insects. With a tail almost half their length, the glossy black, iridescent males make a sharp contrast with the much smaller, brown females. Seldom found far from saltwater, they're a sight to see as they stroll along, pecking and probing with their big beaks. –VC

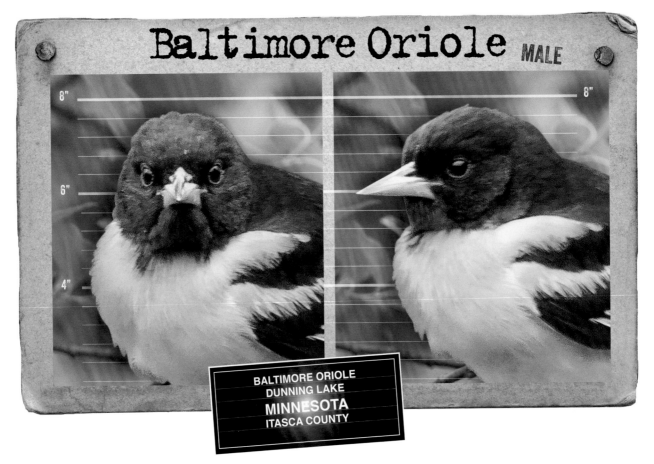

Baltimore Oriole MALE

8"

8"

6"

4"

BALTIMORE ORIOLE
DUNNING LAKE
MINNESOTA
ITASCA COUNTY

MUG SHOT: The solid black feathers on the back, head and wings of this bird, and the flaming orange feathers on the chest and belly, identify this Baltimore Oriole as a male. He has a dagger-like silver-black beak. The front view shows that his upper mandible is flat on top but has a ridge down the middle from his head to the end of the beak. His eyes are positioned toward the front; most songbirds' eyes are more on the sides of their heads. –EO

NATURAL HISTORY: One of our most brilliantly colored songbirds, the Baltimore Oriole has a melodious song, its rich whistles a sure sign that spring is on its way. Look for them in open woods, along rivers in tall trees and in small groves. Orioles are known for their remarkable hanging nests, woven from plant fibers by the female into a purse-like structure. These become visible on leafless trees in the fall. They visit bird feeders for nectar and grape jelly, and in the wild seek out the darkest of ripe fruits. During nesting season they switch to an insect diet for their offspring and themselves. –VC

American Goldfinch

MALE

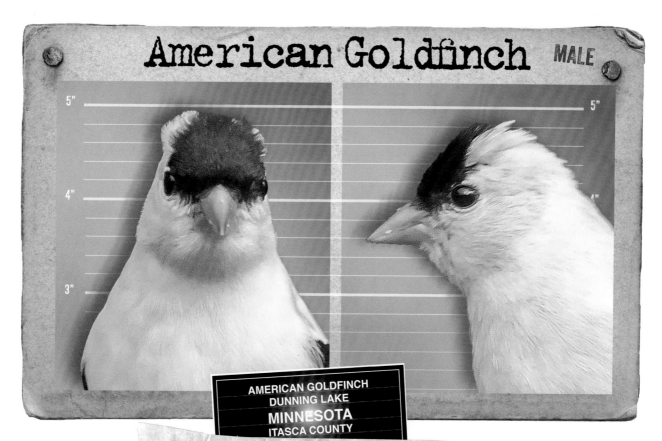

5"

4"

3"

5"

4"

AMERICAN GOLDFINCH
DUNNING LAKE
MINNESOTA
ITASCA COUNTY

WHAT DO YOU SEE?

Enter your own observations below

Evening Grosbeak MALE

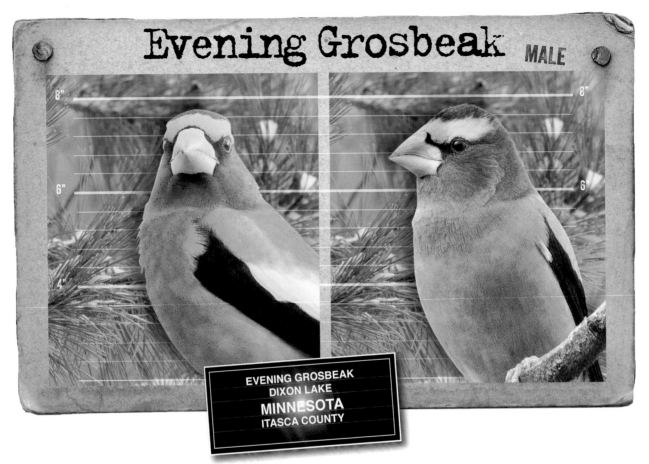

EVENING GROSBEAK
DIXON LAKE
MINNESOTA
ITASCA COUNTY

MUG SHOT: This is a male Evening Grosbeak. One meaning of the word "gross" is bulky, so grosbeak is certainly an appropriate name for this bird. The beak isn't long but it is stout and looks massive in the front view. It's so strong it can even crack hard cherry seeds. The bird's plumage color is the same all year but its beak color gets more intense in the spring. A wide band of yellow feathers above each eye continues across the bird's forehead. —EO

NATURAL HISTORY: Evening Grosbeaks are singularly beautiful birds, and oddly enough, they're classified as songbirds but don't really have a song. Instead, listen for their loud, chirpy calls and buzzy notes. These gregarious birds roam over a large area, feasting on insects in summer and tree seeds and the fruits of shrubs in winter. A large group will suddenly appear at bird feeders, consuming so many sunflower seeds at one sitting that they've earned the nickname, "feeder hogs." Their habit of showing up to feast on spruce budworm caterpillars is often an indication of an upcoming outbreak of these serious forest pests. —VC

Pine Grosbeak MALE

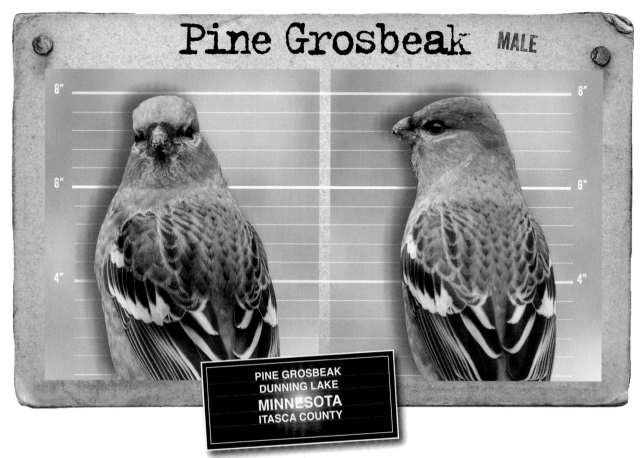

PINE GROSBEAK
DUNNING LAKE
MINNESOTA
ITASCA COUNTY

MUG SHOT: The Pine Grosbeak has a beautiful, intricate pattern of black and white feathers on its back and wings. This bird's overall red color means it's an adult male; females are gray and yellow. The side view shows that the name "grosbeak" might not be particularly appropriate; its beak is quite short and not very stout. Both views show a tuft of black feathers around the top of the beak. A black eye ring can be seen in the side view. –EO

NATURAL HISTORY: Pine Grosbeaks have a vegetarian diet, made up primarily of buds, seeds and fruit from a wide variety of trees. They may be found foraging in ash, spruce, pine, juniper, birch, maple, mountain ash, crabapple and other trees. These birds of the North and Mountain West are relatively tame and don't immediately take flight when startled, allowing for a fairly close approach. They sometimes move southward in winter in small invasions called irruptions, when food supplies are scarce in the northern reaches of their range. One way to detect this handsome bird is to listen for its short, musical warble. –VC

"Two for One" Photos

Sometimes I get lucky and photograph both a side view and a front view with just one photo. Here are some of those shots. I call these my "2 for 1" photos. –EO

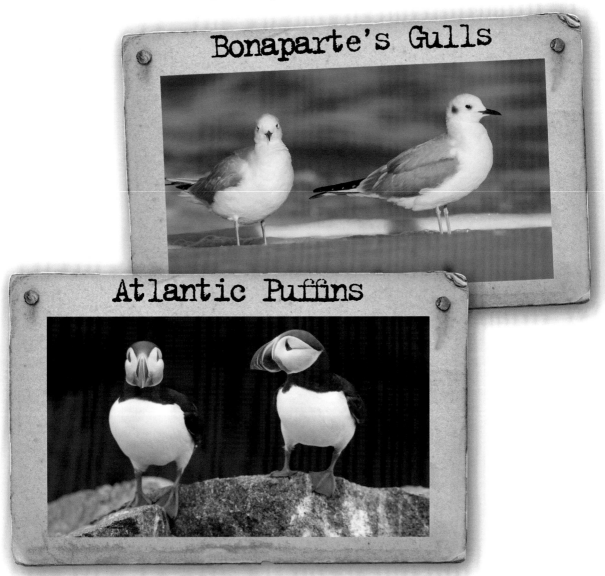

Bonaparte's Gulls

Atlantic Puffins

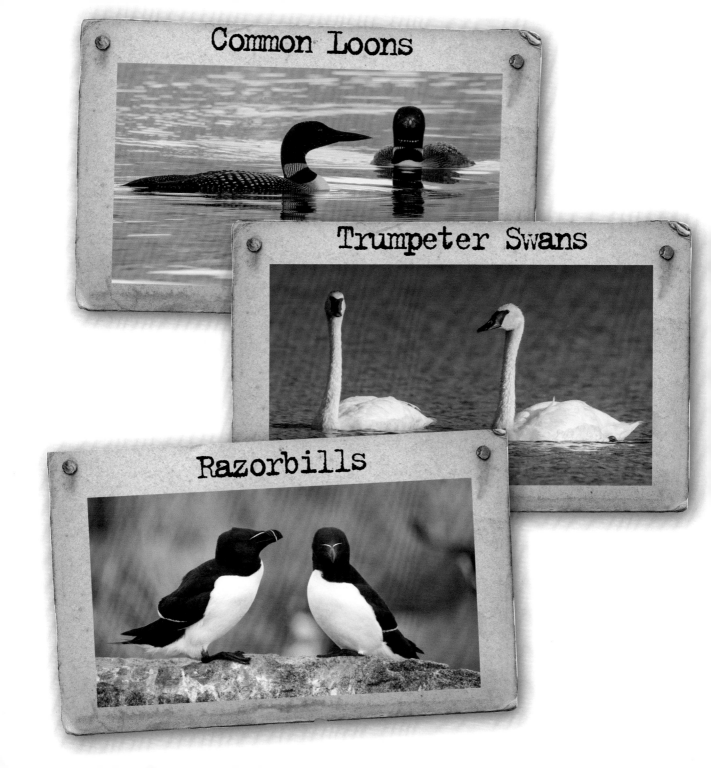

Common Loons

Trumpeter Swans

Razorbills

Glossary

Binocular vision – Using both eyes so there is an overlapping field of vision, providing good depth perception.

Cere – An enlarged fleshy area at the base of some birds' beaks.

Crest – A tuft of feathers on top of the head of a bird.

Dabble – Search with the bill in shallow water for food on the bottom. A common activity for ducks and geese.

Facial disc – A concave collection of feathers on the face of a bird, especially in owls.

Game birds – Birds that are legally hunted by humans such as grouse, turkeys and pheasants.

Gizzard – A muscular part of a bird's digestive tract where food is ground down into small parts.

Gleaning – Birds foraging for food by plucking it from leaves or the ground.

Invertebrate – An animal without a backbone.

Iridescence – A surface that changes color as the angle of the light hitting the surface changes.

Mandible – Either the upper or lower part of a bird's beak.

Mollusk – A large group of animals, like snails and clams, that have a soft body with no backbone. They usually live in a shell.

Nail – A hard growth on the upper mandible of some soft-billed birds, such as ducks and geese.

Omnivore – An animal that eats both plant and animal matter.

Ornithologist – A scientist who studies birds.

Plant gall – An abnormal growth on a plant, usually due to an insect or mite.

Raft – A large group of waterfowl resting on the water.

Index

acorn 63
Africa 24
Alaska 29, 48
American Goldfinch 101
American Kestrel 40
American Redstart 74
American Robin 66
American Tree Sparrow 89
American White Pelican 18
American Wigeon 12
"angry bird" 28
ants 59, 91
Arctic 89
Arizona 52
arrowhead 10
Atlantic Puffin 32, 104
Audubon's Warbler 83
Bachman's Sparrow 93
"back stacking" 34
Baja California 29
Bald Eagle 42
baldpate 12
Baltimore Oriole 100
Barred Owl 45
bats 57
bay berries 82
beetles 48, 59, 60, 68, 73, 83, 85
binocular vision 35
birch 103
Bittern, Least 26
Black Oystercatcher 29
Black-and-white Warbler 75
Black-capped Chickadee 64
Black-throated Green Warbler 79
Black-throated Sparrow 92
Blackbird,
—Red-winged 96

—Yellow-headed 97
Blackburnian Warbler 73
Blue Jay 62
Blue-headed Vireo 59
Blue-winged Warbler 80
bluebill 11
Bluebird, Eastern 67
Boat-tailed Grackle 99
Bobolink 98
Bonaparte's Gull 104
boreal forest 59
broken bones 35
Brown Pelican 19
Bufflehead 13
Bunting, Painted 87
butterball 13
butterflies 53, 60
cactus 88, 92
camouflage 46
Canada 7, 13, 48, 59
Canada Goose 5
Canada Warbler 81
Canadian Flycatching Warbler 81
Canvasback 9
Cape May Warbler 76
Caracara, Crested 37
Cardinal, Northern 86
Caribbean 21, 87
carpenter ants 57
caterpillars 59, 60, 73, 84, 85, 91
Cattle Egret 24
cavity nest 67
Cedar Waxwing 69
centipedes 63
Chestnut-sided Warbler 70, 71
Chickadee, Black-capped 64
Clay-colored Sparrow 91

Common Eider 8
Common Goldeneye 6
Common Loon 14, 105
Common Merganser 15
Common Raven 61
Common Yellowthroat 84
Cooper's Hawk 35
coyote 50
crabapple 69, 103
crabs 29, 30
crayfish 20
Crested Caracara 37
crustaceans 25
damselflies 85
DDT 38, 41, 42
desert 92
dogwood 69, 83
Downy Woodpecker 54
dragonflies 60
drumming 49, 54
Duck,
—American Wigeon 12
—Bufflehead 13
—Canvasback 9
—Common Eider 8
—Common Merganser 15
—Greater Scaup 11
—Lesser Scaup 11
—Redhead 9
—Ring-necked 10
ducks 57
Duluth, Minnesota 28
Eagle, Bald 42
Eastern Bluebird 67
Eastern Screech-Owl 46
Egret,
—Cattle 24

Index

—Snowy 25
Eider, Common 8
Evening Grosbeak 102
"eyebrows" 48
facial disk 44, 45, 47
Falcon, Peregrine 41
"fast food gulls" 31
feather eating 16
"feeder hogs" 102
"fire throat" 73
fires 37
fish 25, 31, 33, 38, 46, 52, 99
"fishsicles" 42
Flicker, Northern 13
Florida 36, 99
"flying monkeys" 61
flying squirrels 57
"flying tigers" 47
Fox Sparrow 90
frogs 24, 25, 26, 46, 50, 99
fruit 103
galls 54
"Giant" Canada Goose 5
Golden-crowned Kinglet 65
Golden-winged Warbler 80
Goldeneye, Common 6
Goldfinch, American 101
golf courses 67
Goose,
—Canada 5
—Giant Canada 5
Grackle, Boat-tailed 99
grass seeds 91
grasshoppers 24, 40
Great Blue Heron 23
Great Gray Owl 44
Great Horned Owl 47

Greater Roadrunner 50
Greater Scaup 11
Grebe, Horned 16, 17
Green Jay 63
Green Kingfisher 52
Grosbeak,
—Evening 102
—Pine 103
Grouse,
—Ruffed 49
—Spruce 48
Gulf Coast 22, 25, 30, 99
Gull,
—Bonaparte's 104
—Ring-billed 31
Hairy Woodpecker 55
Harris's Hawk 34
Hawk,
—Cooper's 35
—Harris's 34
hawthorn 69
hayfields 98
Heron,
—Great Blue 23
—Tricolored 22
Honduras 63
Horned Grebe 16, 17
House Sparrow 67
Hummingbird, Ruby-throated 51
Ibis, White 20
irruption 103
Jay,
—Blue 62
—Green 63
jelly 100
juniper 69, 83, 103
Kestrel, American 40

Kingfisher, Green 52
Kinglet, Golden-crowned 65
Kite, Snail 36
Lake Superior 41
landfills 31
Least Bittern 26
Lesser Scaup 11
lichen 72
limpets 29
lizards 37, 50, 63
Loon, Common 14, 105
Machias Seal Island 32
magnolia tree 78
Magnolia Warbler 78
mangrove swamps 20
maple 103
mayflies 73, 84, 85
meadows 98
Merganser, Common 15
Mexico 87, 88
migration 98
mimicry 63, 68
Mockingbird, Northern 68
mollusks 21, 29
mosquitoes 85
mothlike flight 43
moths 59, 60, 84, 85
mountain ash 69, 103
Mountain West 103
Mourning Doves 35, 40
mulberry 69
muskrats 47
mussels 11, 29, 99
Myrtle Warbler 82
Nashville Warbler 77
nectar 76
nest 100

Index

nest building 59, 72
nest cavity 57
Northern Cardinal 86
Northern Flicker 13
Northern Mockingbird 68
Northern Parula 72
oak 93
oil spills 29
Olive Sparrow 88
Oriole, Baltimore 100
Osprey 38, 39, 42, 47
Owl,
—Barred 45
—Eastern Screech- 46
—Great Gray 44
—Great Horned 47
—Short-eared 43
owls 57
Oystercatcher, Black 29
Painted Bunting 87
Parula, Northern 72
Pelican,
—American White 18
—Brown 19
Peregrine Falcon 41, 47
pesticides 41, 42, 98
pigeons 35
Pileated Woodpecker 57
pine 93, 103
Pine Grosbeak 103
pine martens 57
pine needles 48
plant buds 91
plunge-diving 19
poacher 12
poison oak 83
pondweed 10

Puffin, Atlantic 32, 104
rabbits 45
Rail, Virginia 27
rattlesnake 50
Raven, Common 61
Razorbill 33, 105
Red-bellied Woodpecker 56
Red-eyed Vireo 58
Red-tailed Hawk 47
Red-winged Blackbird 96
Redhead 9
Redstart, American 74
Ring-billed Gull 31
Ring-necked Duck 10
Roadrunner, Greater 50
Robin, American 66
Rock Pigeons 41
rodents 31
Roseate Spoonbill 21
Royal Tern 30
Ruby-throated Hummingbird 51, 53
Ruddy Turnstone 28
Ruffed Grouse 49
sap 53
Sapsucker, Yellow-bellied 53
sawbill 15
Scaup,
—Greater 11
—Lesser 11
Scoter, White-winged 7
Screech-Owl, Eastern 46
"sea parrot" 32
seeds 103
serviceberry 69
Short-eared Owl 43
shrimp 21, 30, 33, 52, 99
skunks 47

Snail Kite 36
snails 21, 36
snakes 26, 37, 50
Snowy Egret 25
South America 81, 98
Spanish moss 72
Sparrow,
—American Tree 89
—Bachman's 93
—Black-throated 92
—Clay-colored 91
—Fox 90
—Olive 88
—White-crowned 94
—White-throated 95
spiders 63, 91
Split Rock Lighthouse 41
Spoonbill, Roseate 21
spruce 103
spruce budworm caterpillar 73, 76, 102
Spruce Grouse 48, 99
spruce needles 48
squid 30, 33
squirrels 47, 53
starlings 35
Swan, Trumpeter 4, 105
tadpoles 99
Tamarack needles 48
Tennessee 77
Tern, Royal 30
Texas 52, 63, 88
"thin as a rail" 27
toads 50
tree cavity 15
Tricolored Heron 22
Trumpeter Swan 4, 105
tundra 89

Index

Turnstone, Ruddy 28
Vireo,
—Blue-headed 59
—Red-eyed 58
—Yellow-throated 60
Virginia Rail 27
voles 44
Warbler,
—Audubon's 83
—Black-and-white 75
—Black-throated Green 79
—Blackburnian 73
—Blue-winged 80
—Canada 81
—Cape May 76
—Chestnut-sided 70, 71
—Golden-winged 80

—Magnolia 78
—Myrtle 82
—Nashville 77
—Yellow 85
—Yellow-rumped 82, 83
"warbler neck" 73
water lily 10
wax myrtle 82
Waxwing, Cedar 69
whelks 29
whistler 6
White Ibis 20
White-crowned Sparrow 94
White-throated Sparrow 95
White-winged Scoter 7
wild celery 10
wild cherry 69

wild rice 10
William Tell Overture 72
"witchety bird" 84
Woodpecker,
—Downy 54
—Hairy 55
—Pileated 57
—Red-bellied 56
worms 31, 46
Yellow Warbler 85
Yellow-bellied Sapsucker 53, 76
Yellow-headed Blackbird 97
Yellow-rumped Warbler 80, 81
Yellow-throated Vireo 60
Yellowthroat, Common 84
Zebra Mussel 7
"zebra warbler" 75

Other Books by Stone Ridge Press